F R E N C H
M O D E R N

STEVEN HELLER ✳ LOUISE FILI

FRENCH

MODERN

ART DECO GRAPHIC DESIGN

CHRONICLE BOOKS · SAN FRANCISCO

The authors are indebted to our editor at Chronicle Books, Bill LeBlond, for his continued support of this series; we also thank Michael Carabetta, art director; Martine Trélaün, art coordinator; Sarah Putman, editorial assistant. Thanks to Mary Jane Callister for her design assistance, to Tonya Hudson at Louise Fili Ltd, and to Austin Hughes for additional photography.

Thanks also to Kurt Thaler, Catherine Bürer, Barbara Meili, and B. Hausmann at the Platkatsammlung Museum für Gestaltung Zürich; Jacqueline Eberhard at Nestlé S.A.; Sophie Henley-Price at Somogy Editions d'Art; Gail Chisholm at the Chisholm Gallery, New York; Anita Gross at The Wolfsonian Foundation; James Fraser at Fairleigh Dickinson University Library; and Mirko Ilić.

CREDITS

Chapter title images are from the 1926 catalog for Fonderies Deberny & Peignot. With the exception of the following, all materials in this book are on loan from private collections. Platkatsammlung Museum für Gestaltung Zürich: 72, 79 (right), 85 (both), 88 (left & middle), 93, 94, 104 (top right, top left), 105, 106, 107 (left, top middle, right); Courtesy Nestlé S.A.: 78 (left), 80 (all); Wolfsonian Foundation: 21, 27, 101; Mirko Ilić: 117; Posters Please Inc.: (Paulette Duval 26) (Georges Irat 111); Courtesy Reinhold Brown: (L'Intrans 28, Grand Sport 39, Wagon-Bar 107 [bottom middle]); Gewerbmuseum; Basel Museum für Gestaltung: (Odeon 29).

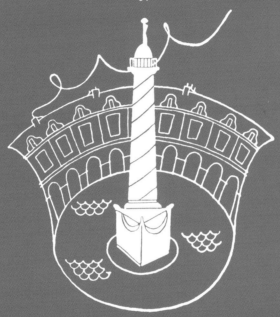

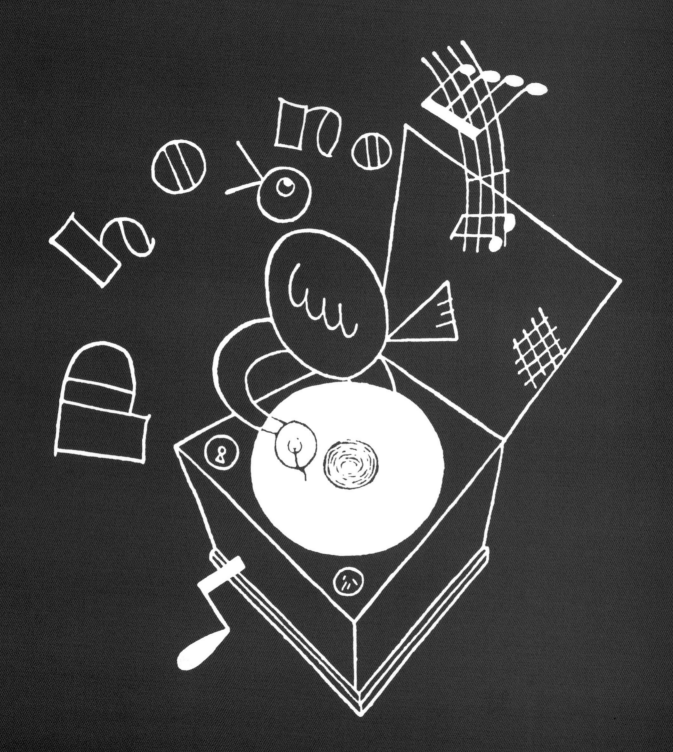

Early-twentieth-century Paris was a nexus of culture and commerce and a center for both modern painting and modern advertising. While painters altered the canvas, commercial artists popularized the avant-garde through ubiquitous bills and posters. Following France's victory in World War I, the public, eager to resume prewar consumption, was introduced to contemporary art forms through a plethora of advertisements for the *grands magasins* (department stores), automobiles, liquors, and cosmetics. French business and industry were the first in Europe to claim Modernisms, especially Cubism, as tools of *la publicité*, which led to a flurry of disparaging comments by orthodox Moderns such as Le Corbusier and Ozenfant, who charged that French advertising was "fake, marked-down" Cubism. Nevertheless, the public was made visually literate not by visiting Paris's great

INTRODUCTION

museums or galleries, but by strolling along its broad boulevards, where, during the 1920s and '30s, the billboards and kiosks were covered with pictorial iconography and decorative letterforms. "Advertising leads the public to acquire new tastes, just as it is led to buy products," wrote French graphic design critic A. Tolmer in *Modern Publicity* (1930). "The space allotted and the place held by advertisement display in our leading exhibitions of decorative art is, in itself, sufficient proof that advertising is definitely regarded as a branch of decorative art." Likewise, the leading Parisian poster artists A.M. Cassandre, Charles Loupot, Jean Carlu, and Paul Colin were recognized by business and public alike as cultural figures just as important in their métier as Picasso and Braque were in theirs.

French Modern graphic design was born in the *ateliers d'art*, or advertising departments, of the *grands*

magasins—first in 1912 at the Printemps department store, and later at Galeries Lafayette, Bon Marché, and Louvre. "[They] wield in two directions," design critic Marcel Valotaire explained. "The first is their attractive window-dressing, and the second their system of catalogues which are sent out to the provinces each season." Like dimensional paintings, the window showcases combined fashion, interior, and graphic design into a Modernistic ensemble that influenced other graphic media. The catalogs were adorned with posterlike covers and filled with stylized, often geometric renderings of sleek models dressed in the modes then reigning in Paris. Through the confluence of advertising and the products being advertised, Paris quickly became the European wellspring of commercial modernity.

France built its economy on commercial Modernism. In contrast to Art Nouveau, which certainly had an impact on the Parisian cityscape but failed to achieve widespread public acceptance, Art Deco and its derivatives were ubiquitous in all forms, from buildings to matchboxes. In a nation that suffered the ravages of war, Art Deco came to symbolize not merely a return to prewar norms, but to postwar prosperity. And business was quick to realize that any tool that stimulated and increased consumption was worth encouraging. Advertising agencies, poster ateliers, and type shops grew furiously to meet the insatiable demands of business and industry.

The concurrent rise of industry and consumerism in post–World War I France demanded more from advertising on every level and provided the rationale progressive artists needed to defy the norms. In a challenge to the academic conventions of advertising art, the new *affichistes*, or poster-makers, influenced by modern art and machine-age aesthetics, rejected Romantic and ornamental rendering in favor of flat, constructed form. With

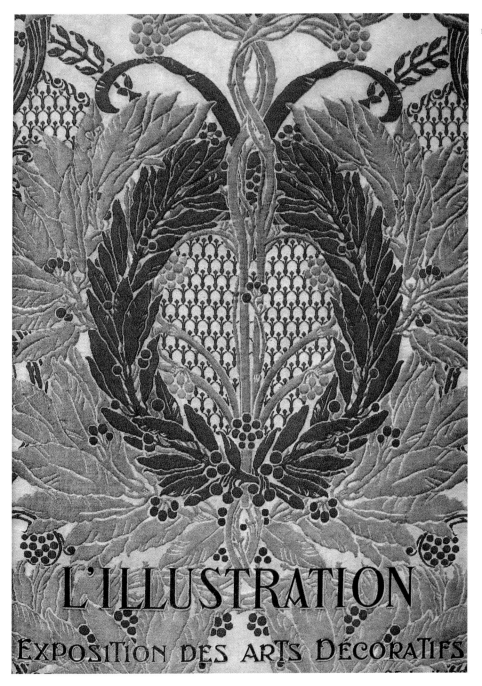

L'ILLUSTRATION
MAGAZINE COVER, 1925
ARTIST UNKNOWN

its foundation in geometry, the new poster was not loosely sketched or painted as before, but rather deliberately

built, as Cassandre described it, on a "precise architectural method." The style was characterized by fragmenta-

tion, abstraction, and overlapping imagery in keeping with Cubo-Futurist collage.

By 1925 avant-garde techniques had been adopted for their novelty, and in 1928 the editors of England's

leading advertising trade publication *Posters & Publicity: Fine Printing and Design "Commercial Art" Annual*

noted that arguments within professional circles about modern and nonmodern approaches had become as stale

as arguments between the Classical and Romantic schools. "If a design that takes some of the elements of mod-

ern art as a working basis accomplishes the end of selling goods, it accomplishes what is expected of it," the edi-

tors wrote. But they also claimed that in France, "artists follow too far their own individual path, that is, they tend to aim at purely aesthetic standards which are not necessarily good advertising." French *publicité* might have been more symbolically abstract than, say, realistic English or American advertising, but it did not require that the viewer strain in order to comprehend the message. And the innovators of French advertising art did fundamentally alter how messages were communicated. Through compositions inspired by contemporary painting rather than printers' layout manuals, products were not merely announced, but given auras that appealed to consumers at conscious and subconscious levels simultaneously.

Modern psychology taught advertisers the value of unlocking the subconscious, and modern art gave them the key. The audacious application of collage from Cubism, discordant typography from Futurism, and color-field abstraction from DeStijl captured viewer attention. Advertising pundits called the mnemonic image that prompted a kind of Pavlovian recognition "the fatal dart." The most memorable campaigns were the reductive ones that used a formidable design scheme to frame an unmistakable icon. "If painting has become simpler and more brutal, it is because a simple and brutal statement is at once formulated and understood more quickly. It is easy to see why publicity has borrowed from painting a mode of expression so suitable for its own needs," wrote A. Tolmer in *Mise en Page* (1931), the bible of French Modern layout. But if this statement appears to contradict the general perception of Art Deco as a fount of excessive ornamentation—the term *Art Deco* was coined in the 1960s to suggest the multifaceted style of the 1920s and '30s originally referred to as Moderne or Modernistic—it is important to understand that the French Modern graphic style between the world wars took

many different forms. French Modern ran the stylistic gamut from the sumptuous ornamentation of high Deco's early Egyptian-Mayan hybrid neoclassicalism, to the brutal geometry of synthesized Cubism, to the spartan simplicity inspired by the Bauhaus and Purism.

Art Deco replaced the floriated madness known as Art Nouveau, which held sway for a brief period between the late nineteenth and early twentieth centuries. By the time Art Deco arose, Art Nouveau had devolved into a mélange of decorative eccentricities in which serpentine tendrils of stylized plants strangulated every designed object from furniture to jewelry to graphics. For some, the difference between the two styles was simply bad versus good taste; formally speaking, the fundamental shift was from curvilinear to rectilinear.

After the ostentatious artifice that preceded it, the straight line became the paradigm of beauty. Yet as in Art Nouveau, the ornamental motifs of early Art Deco were flowers, animals, and nymphs, as well as geometric patterns consisting of zigzags, chevrons, and lightning bolts. During this early phase, designers playfully borrowed ancient Egyptian, Mayan, and Oriental ornaments that were first introduced by Léon Bakst in his scenery and costumes for the influential Ballets Russes. The style appeared in the years before World War I, but was officially introduced seven years after the war's end, in April 1925, at the *Exposition des Arts Décoratifs et Industriels Modernes*, a world's fair of commercial products and style. In the *"pavillions de l'élégance,"* as the showrooms were described in *L'Illustration* magazine (August 8, 1925), France's leading retailers displayed furniture and fashions that marked the pinnacle of high Art Deco and Gallic eccentricity. But the *Exposition* also marked the thrust away from this elitist phase toward a mass-oriented one.

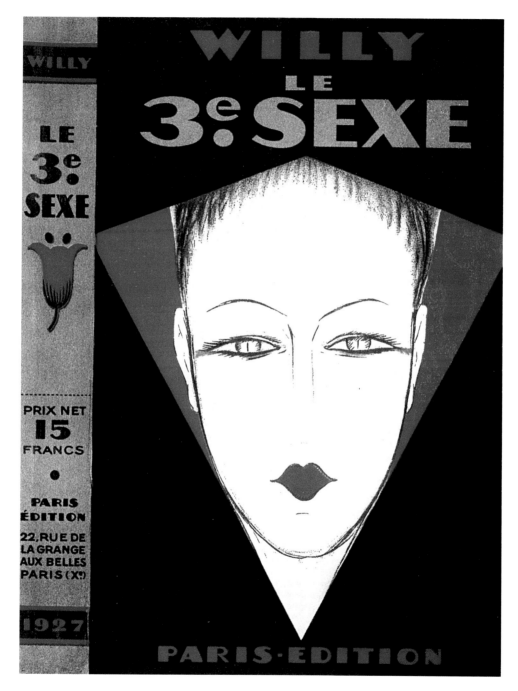

LE 3ᴱ SEXE
BOOK JACKET, 1926
ARTIST UNKNOWN

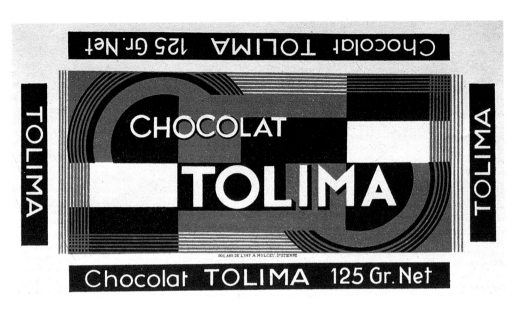

Decorative art had always been the prerogative of the rich, but in post–World War I Europe, the working and middle classes soon dictated their aesthetic needs, too. Modernists throughout Europe agreed that good design should be made available to everyone. And, depending on the social and political tenor of a particular nation, quality mass production was championed as a more-or-less inviolable right. But mass production requires standardization, and ornament was generally the first element to be sacrificed to the exigencies of production, both for functional and symbolic reasons.

Although the orthodox Modernists proffered a spartan functionalism that resulted in the elimination of bourgeois decorative excesses, most commercial designers without ideological leanings, especially in France, favored a reevaluation of form based on the dictates of the new era and opted for a middle ground which did not entirely eschew ornamentation. For the design of machines, appliances, and furniture, this meant conform-

ing to, and building beauty into, the new industrial processes and coining a new ornamental vocabulary. For graphics, this meant complementing the industrial arts. This middle ground was best described by Marcel Valotaire, who said in "Continental Publicity" (*Commercial Art*, 1929) that to succeed, an advertisement must "give prominence to the product while practicing abstraction." This implied that graphic design should not be neutral, but should straddle the line between avant-garde and accessible. Ultimately, the public benefited from a revolution in design that did not so abruptly alter their tastes, but gave them a comfortable contemporary style that was of its time. "We find a growing demand for the new type of modern decorative art in all its varied forms," wrote Valotaire in "The Ateliers of the Grands Magasins of France" (*Commercial Art*, 1928). "It is the modern thing which sells nowadays."

French Modern graphics became the model for other European advertising, and some of the key artists exported their talents around the world. Within this milieu, type founding was another exportable industry. Although much of the lettering in Modern and Moderne posters was drawn by hand, the decorative styles introduced in this medium were in such demand that metal letterforms based on them were prodigiously produced. The poster became the testing ground for new lettering, and various foundries began to design, copy, and pirate original alphabets. None was more in the forefront than Fonderies Deberny & Peignot, which had marketed the most popular typefaces in all France, among them Nicolas Cochin, Moreau le Jeune, and Le Naudin. In the 1930s A. M. Cassandre added to this inventory when he designed Bifur, a unique display face that A. Tolmer called one of the "phenomena of advertising," and Peignot (after the foundry's proprietor, Charles

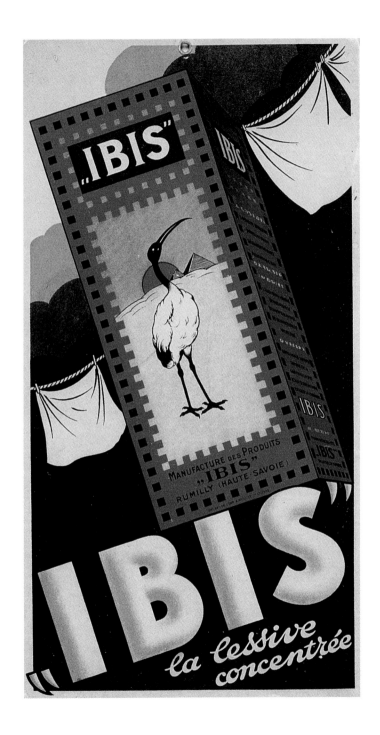

Peignot), which to this day is the quintessential Art Deco typeface. In addition, the French foundries produced sinuous decorative types that in America were dubbed "continental perfume faces" because they were used for that kind of advertising. Driven by market demands, the foundries issued lavish catalogs and specimen sheets, which increased business throughout the world and made French type both a popular export and the paradigm of Art Deco styling.

In 1932 A. Tolmer wrote in *Commercial Art* that French advertising was "advancing further and further beyond the 'easy,' the superficial, and the 'tricks,' which, though they gave the advertisement a certain spontaneous charm, were speedily revealed as tawdry by the facility with which they were acquired by artists of mediocre ability." This analysis of French Modern design is an apt introduction to the examples reproduced in this book. Some are what Tolmer might agree represent the epitome of French Modernism and Moderne styling, while others embody trendy "tricks" and novelties. It is not the purpose of this collection to distinguish between the high and low ends of graphic endeavor, but rather to exhibit the wide range of distinctive Art Deco methods used in posters, packages, point-of-purchase displays, labels, fans, magazines, and logos. Work by the leaders and the followers share the same stage as they did on the kiosks and countertops, in the publications and shop windows of France. Indeed, here the anonymous graphics are given even more prominence, for when presented in a collection these ephemeral works fuse into the quintessence of the French Modern style. This book is a celebration of what A. Tolmer referred to as the "miraculous originality of modern art" and of a period when French graphic design exerted a tremendous influence throughout the world.

Impressionistic poster graphics of the late nineteenth century celebrated and advertised popular culture. These posters became cultural artifacts, and by the early twentieth century advertising artists had been integrated into the cultural scene not as messengers, but as creators. A. Tolmer wrote effusively in *Mise en Page*: "It is curious to find that advertising should in text and style reveal an affinity with ancient art." Not only did Moderne approaches borrow from antiquity, but they were motivated by the ancient craftsman's creed. By the 1920s advertising art had become a full-fledged, respected, and sought-after profession. At the 1925 *Exposition des Arts Décoratifs et Industriels Modernes*, the graphic design of catalogs, posters, and lettering on pavilions contributed to the new cultural (and commercial) image that the French minister of commerce and industry wanted

C U L T U R E

to present to the world. The marriage of art and industry was key to France's emerging modernity; exhibitions and magazines made this clear to the public through symbolic motifs such as the metaphorical flowering of industry on the poster for the 1925 *Exposition*, designed by Charles Loupot. Graphic design was coming of age, which is why it is paradoxical that the final design for this poster was selected by a jury of architects, novelists, and politicians, without an advertising professional in the group. Nevertheless, 1925 marked the ascendancy of graphic design as a bona fide artistic métier. Comparing A.M. Cassandre and Loupot to the modern painting masters Picasso and Braque, A. Tolmer wrote, "the composition of a picture is nothing more or less than a layout." The modern spirit so pervaded French advertising that one commentator said that the "walls of the great city [of Paris are] a picture gallery whose publicity fires at the public at close range."

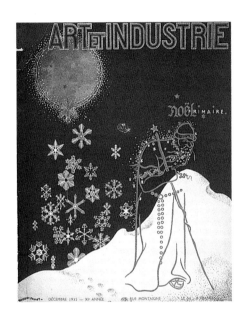

ART & INDUSTRIE

MAGAZINE COVER, 1935

ARTIST: ROBERT FALLOT

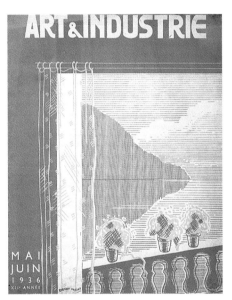

ART & INDUSTRIE

MAGAZINE COVER, 1936

ARTIST: ROBERT FALLOT

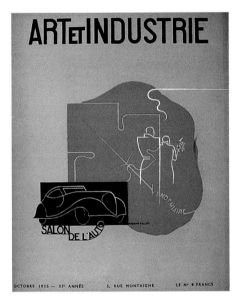

ART & INDUSTRIE

MAGAZINE COVER, 1935

ARTIST: ROBERT FALLOT

OPPOSITE:

EXPOSITION INTERNATIONALE

ARTS DÉCORATIFS &

INDUSTRIELS MODERNES

POSTER, 1925

ARTIST: CHARLES LOUPOT

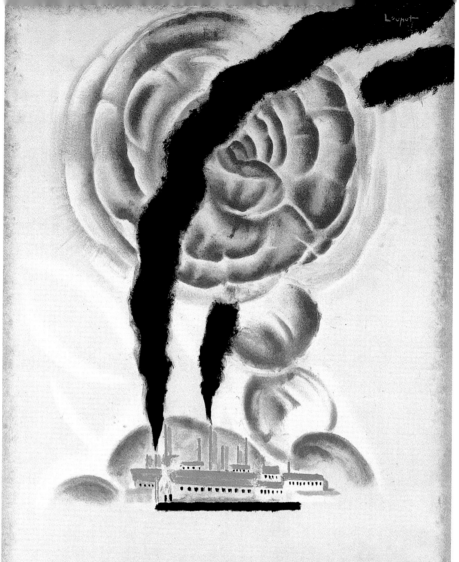

MINISTÈRE DU COMMERCE ET DE L'INDUSTRIE
EXPOSITION
INTERNATIONALE
ARTS DÉCORATIFS
ET INDUSTRIELS MODERNES
AVRIL PARIS . 1925 OCTOBRE

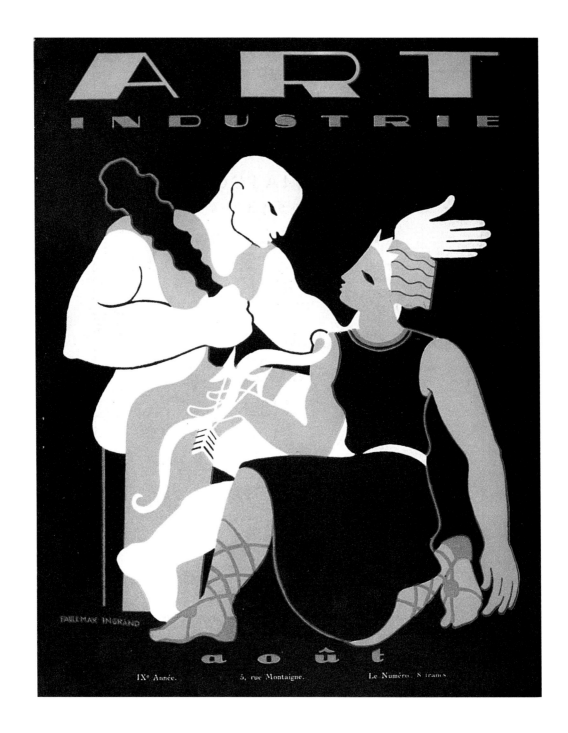

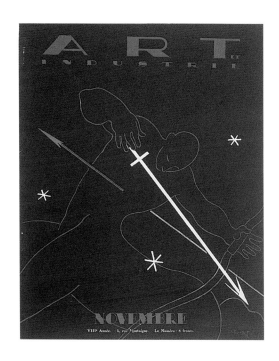

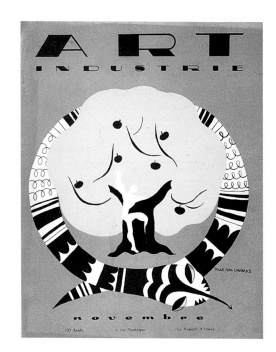

ART & INDUSTRIE

MAGAZINE COVER, 1932

ARTIST: CHARLES LOUPOT

ART & INDUSTRIE

MAGAZINE COVER, 1933

ARTIST: PAULE MAX INGRAND

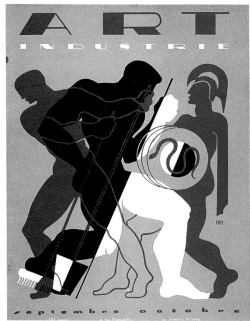

ART & INDUSTRIE

MAGAZINE COVER, 1933

ARTIST: PAULE MAX INGRAND

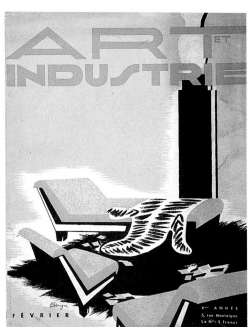

ART & INDUSTRIE

MAGAZINE COVER, 1934

ARTIST: C BÉNIGNI

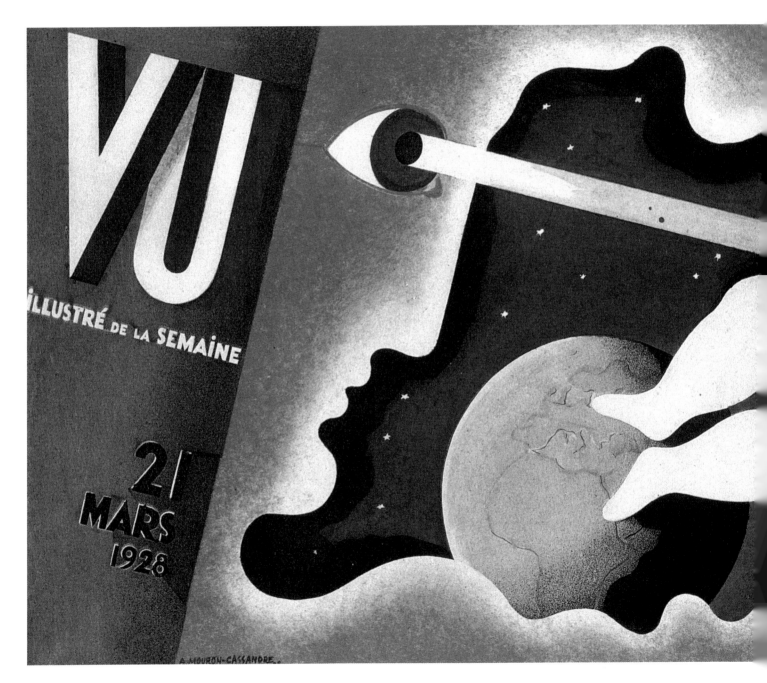

24

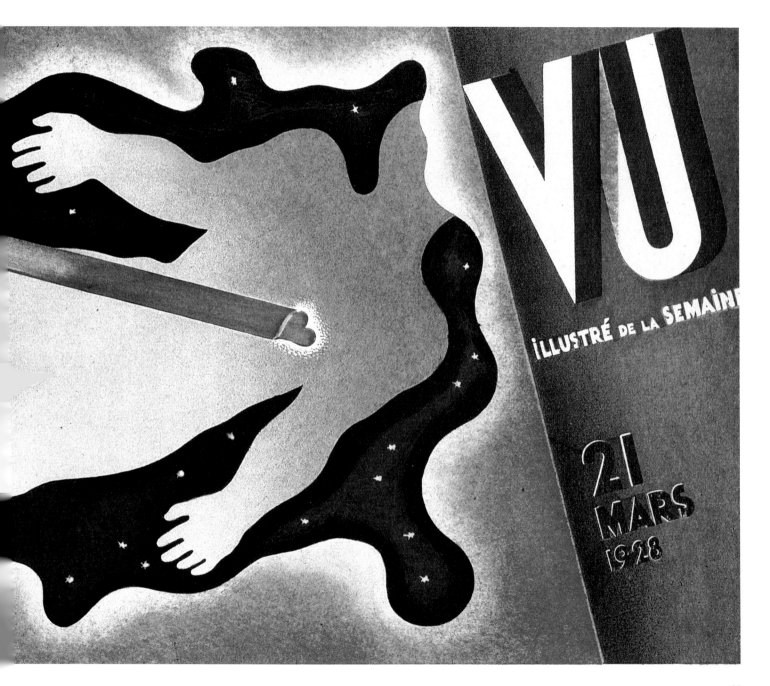

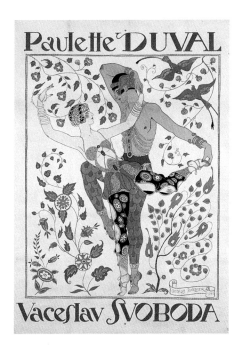

Paulette DUVAL

Vaceslav SVOBODA

LA DANSE

MAGAZINE COVER, 1924

ARTIST: MARIE VASSILICH

PAPYRUS

MAGAZINE COVER, 1925

ARTIST UNKNOWN

DUVAL/SVOBODA

POSTER, 1920

ARTIST: GEORGE BARBIER

LA DANSE

NOVEMBRE-DÉCEMBRE 1924
Numéro consacré aux Ballets Suédois
de Rolf de Maré

BALLETS SUÉDOIS

JEAN BORLIN

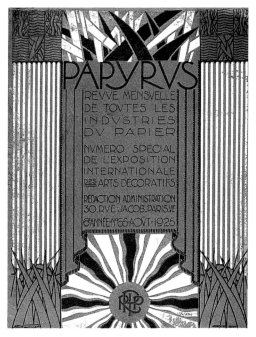

PAPYRVS

REVVE MENSVELLE
DE TOVTES LES
INDVSTRIES
DV PAPIER

NVMERO SPÉCIAL
DE L'EXPOSITION
INTERNATIONALE
DES ARTS DÉCORATIFS

REDACTION ADMINISTRATION
30. RVE JACOB. PARIS.VIE
6 ANNÉE·N°65·AOVT·1925

PREVIOUS SPREAD:

VU

POSTER, 1928

ARTIST: A. M. CASSANDRE

ARTS DÉCORATIFS &
INDUSTRIELS MODERNES
BOOK BINDINGS, 1925
DESIGNER UNKNOWN

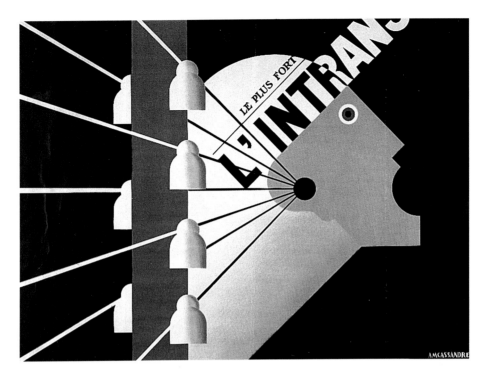

L'INTRANSIGEANT

POSTER, 1928

ARTIST: A.M. CASSANDRE

EDISON BELL

POINT-OF-PURCHASE DISPLAY, c.1933

ARTIST UNKNOWN

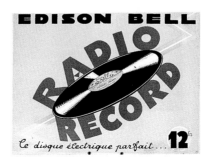

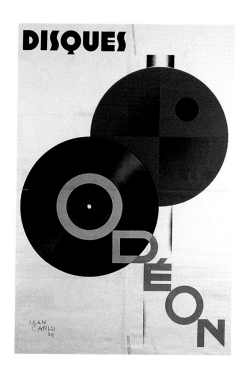

DISQUES ODÉON
POSTER, 1929
ARTIST: JEAN CARLU

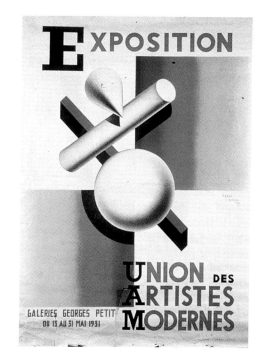

EXPOSITION
POSTER, 1931
ARTIST: JEAN CARLU

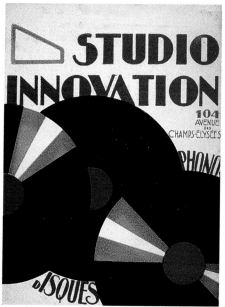

STUDIO INNOVATION
ADVERTISEMENT, c.1930
ARTIST: PAUL COLIN

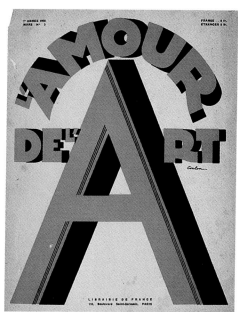

L'AMOUR DE L'ART
MAGAZINE COVER, 1926
DESIGNER: COULON

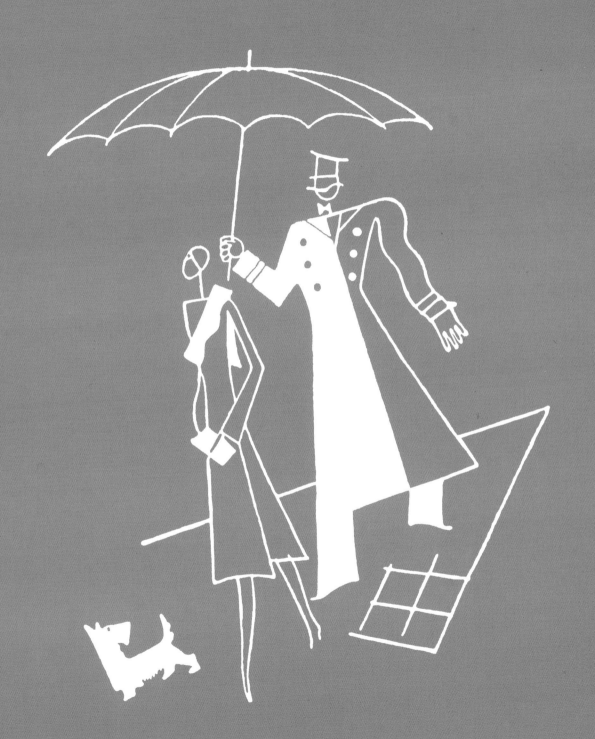

The Paris collections are a seasonal rite that has only twice been interrupted by war. Between the world wars, Paris was the mecca for the great design talents, not the least of whom was Paul Poiret, the leading couturier who in 1911 founded the first modern design academy, *L'Ecole Martine*, and later introduced France to Cubistic trends in fashion. The Moderne style was sleek, supple, and sensual; its simplicity alone was a radical departure from the overwrought complexity of fin de siècle women's garments. Composed of few lines, the elegant contours of the new fashions were also so graphic that they influenced the Modern and Moderne graphic imagery which ultimately introduced fashion to the masses. The market for stylish, French, "off-the-rack" clothes continued to expand throughout the 1920s, and the *grands magasins* were quick to promote their well-

FASHION

stocked emporia through seasonal catalogs featuring the latest zigzag, sawtooth, sun-ray, and rectilinear patterns printed against similarly geometric backgrounds. Graphic designers drunk with colors and shapes were given license to indulge in visual excess in the ways they framed and advertised the new. In September 1929 the editors of England's *Commercial Art* magazine characterized the exuberance of French fashion advertising this way: "The Frenchman takes his business as he takes his recreation, with a lighter heart than we do." And while most consumer nations—even those that had adopted Art Deco—were seriously developing marketing strategies, French graphic design, though no less committed to what marketers called "selling the goods," was also as playful as the market could tolerate and as outrageous as the public would accept. The confluence of a high Deco elegance and a mass-market wit made French fashion graphics the most enticing in the world.

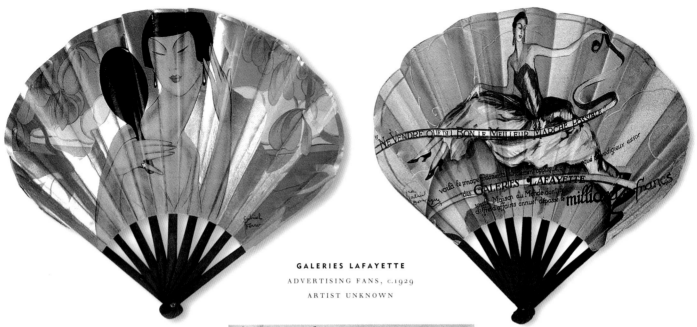

GALERIES LAFAYETTE

ADVERTISING FANS, c.1929

ARTIST UNKNOWN

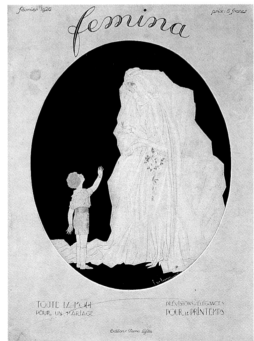

FEMINA

MAGAZINE COVER, 1926

ARTIST: GEORGES LEPAPE

OPPOSITE:

AU LOUVRE

CATALOG COVER, 1937

ARTIST: ALYANKI

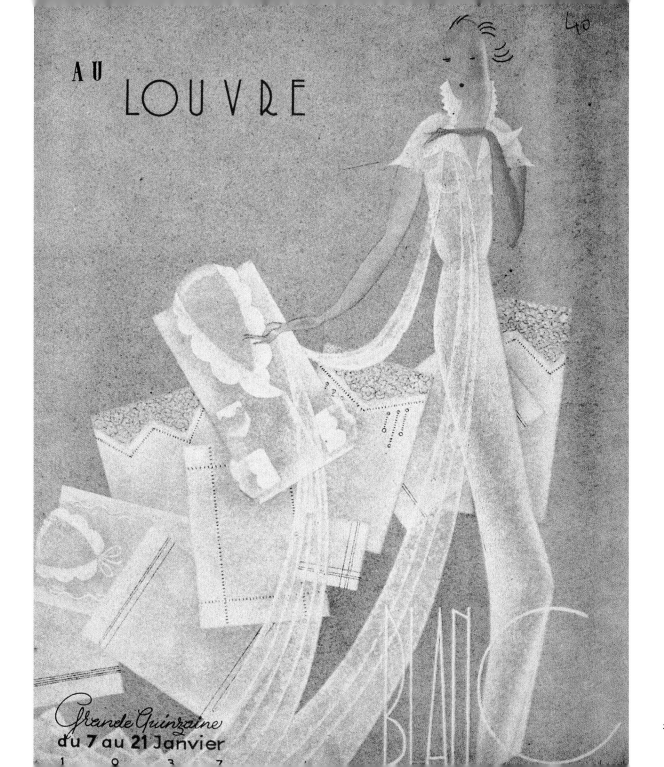

AU LOUVRE

Grande Quinzaine
du **7** au **21** Janvier
1 9 3 7

BLANC

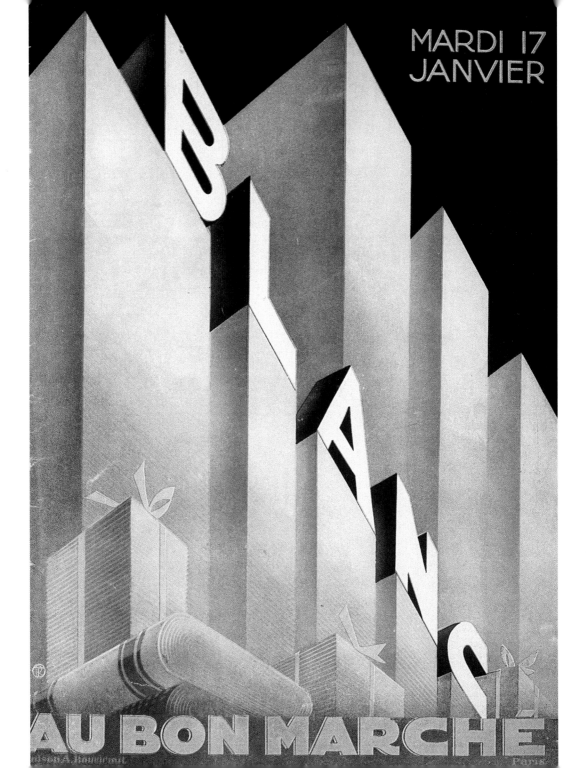

34

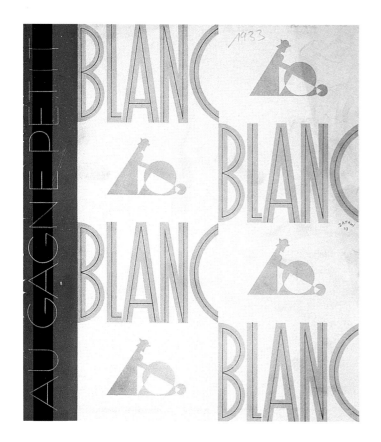

AU GAGNE PETIT

CATALOG COVER, 1933

ARTIST: SATOMI

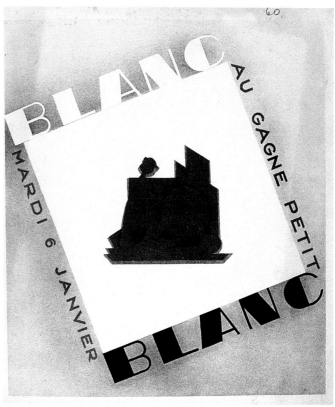

AU GAGNE PETIT

CATALOG COVER, c.1934

ARTIST: GEORGE LANG

OPPOSITE:

AU BON MARCHÉ

CATALOG COVER, 1928

ARTIST: T.R.

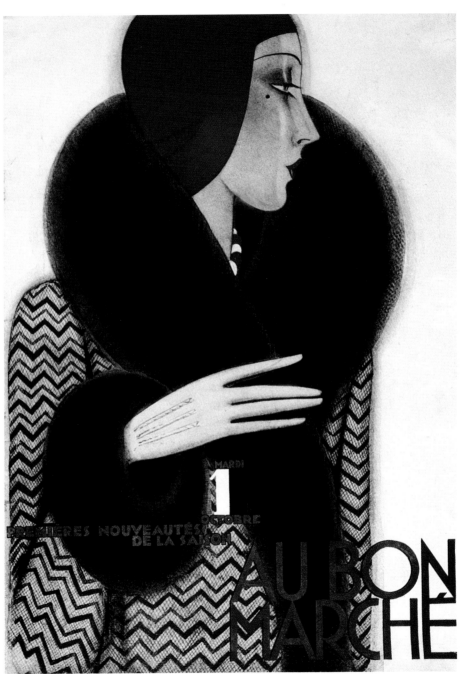

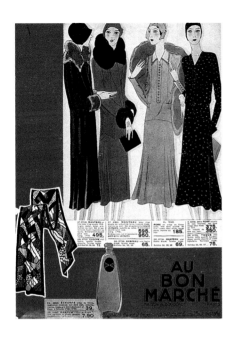

AU BON MARCHÉ

CATALOG COVER, c.1931

ARTIST: HENRI MERCIER

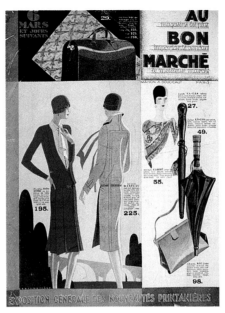

AU BON MARCHÉ

CATALOG COVER, c.1931

ARTIST: HENRI MERCIER

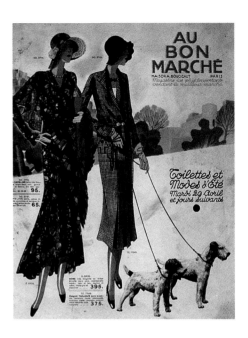

AU BON MARCHÉ

CATALOG COVER, c.1931

ARTIST: HENRI MERCIER

BOUTONS FANTAISIE

PACKAGE, c.1928

DESIGNER UNKNOWN

GOÛT·ART·MODE

PACKAGE, c.1928

DESIGNER UNKNOWN

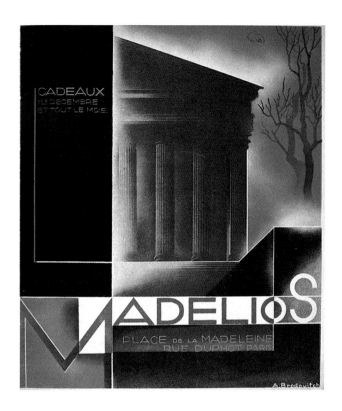

MADELIOS

CATALOG COVER, c.1930

ARTIST: ALEXEY BRODOVITCH

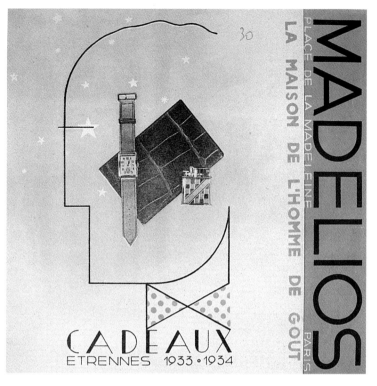

MADELIOS

CATALOG COVER, 1933

ARTIST: L'ESPERANCE

GRAND SPORT

POSTER, 1925

ARTIST: A.M.
CASSANDRE

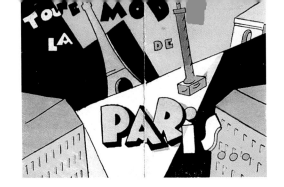

TOUTE LA MODE DE PARIS
FOLDER, c.1929
ARTIST UNKNOWN

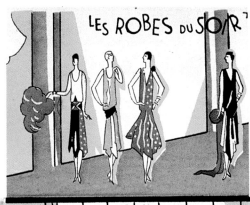

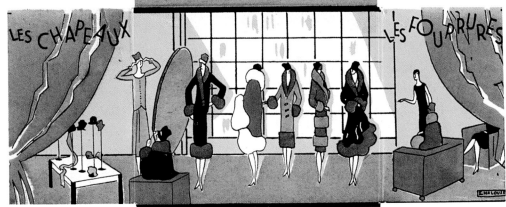

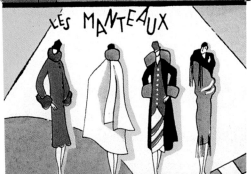

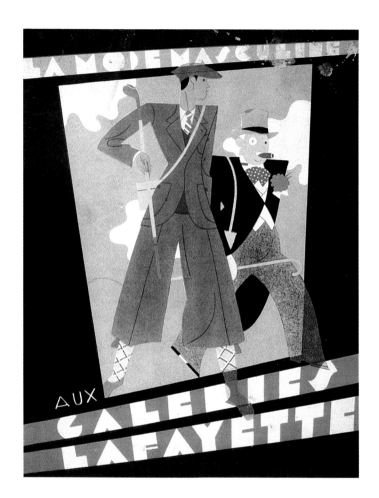

GALERIES LAFAYETTE

CATALOG COVER, c.1929

ARTIST UNKNOWN

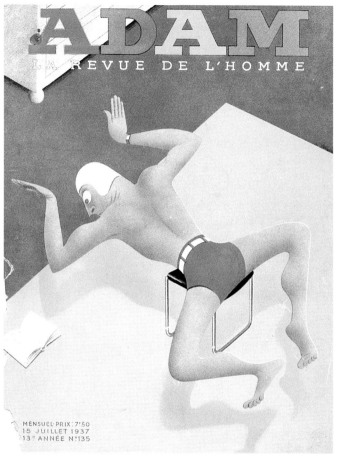

ADAM

MAGAZINE COVER, 1937

ARTIST: PAOLO GARRETTO

RUBAN

LINGERIE ADVERTISEMENT, c.1930

ARTIST UNKNOWN

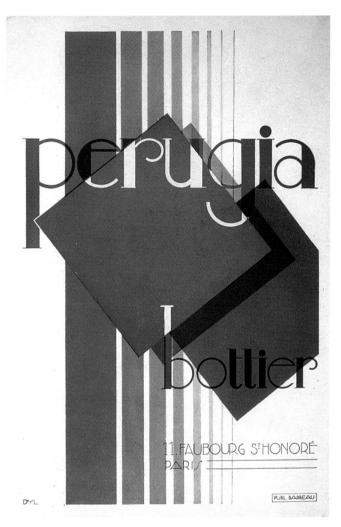

PERUGIA

ADVERTISEMENT, 1932

ARTIST: PUBLICITÉ BARREAU

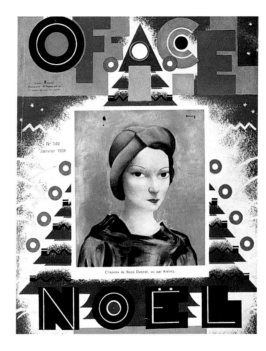

L'OFFICIEL

MAGAZINE COVER, 1931

ARTIST: JEAN DUNAND

L'OFFICIEL

MAGAZINE COVER, 1935

ARTIST: C. BÉNIGNI

L'OFFICIEL

MAGAZINE COVER, 1934

ARTIST: KISHING

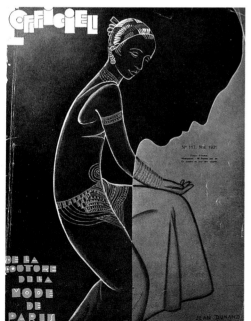

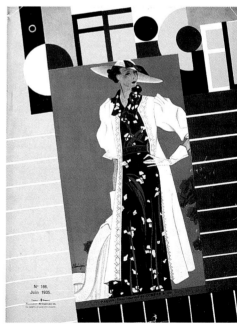

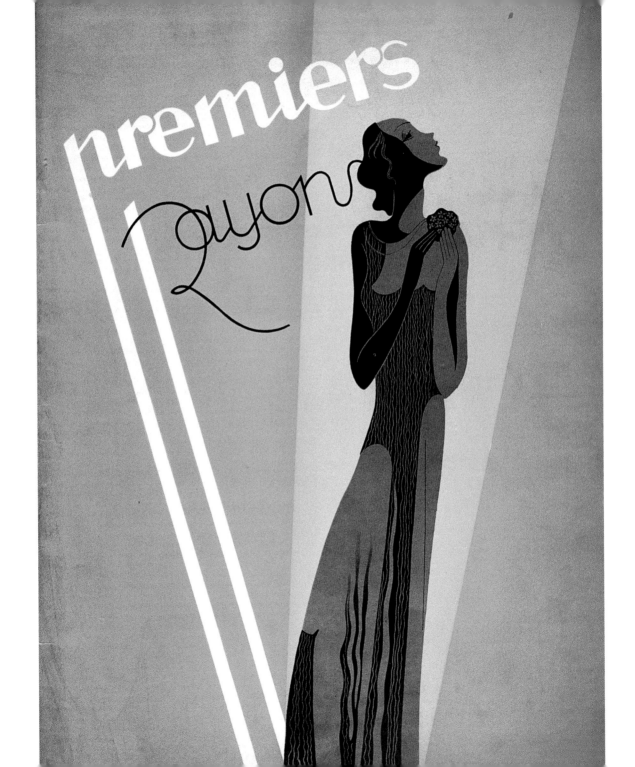

premiers

Rayon

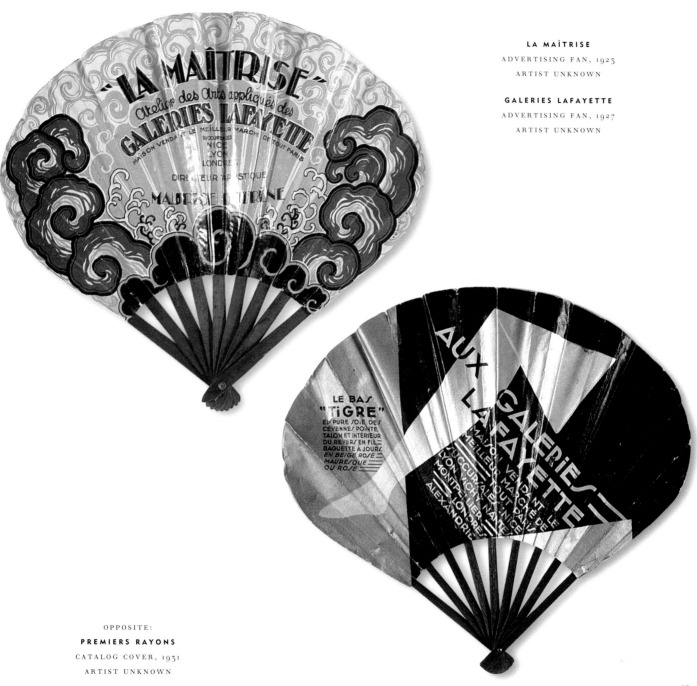

Fashion was the wellspring of French Modern graphic design, and it flowed over into the realms of cosmetics, fragrances, and sundries as well. Fashion advertising for the *grands magasins* was mythic, but the market necessitated that it also appeal to the real-life needs of the consumer. Not so in the area of beauty products. Cosmetics advertisements were based entirely on developing allures for various products that were more or less the same. To package, label, and promote soaps, creams, powders, shampoos, and perfumes, the leading manufacturers hired the services of ateliers where scores of anonymous decorative designers were employed. With the notable exception of posters, graphic design in this realm was reduced to the small-scale image, and designers were forced to use graphic motifs to immediately capture the customer's senses before the competition

B E A U T Y

did. While ostensibly conforming to a Moderne style, many designs came close to echoing certain Art Nouveau conceits. Natural ornamental borders and background patterns were, for example, commonly used to give soap bars an enchanted aura. To complement such suggestive fragrance names as Soyons Discrets (Let's Be Discreet) and Un Rêve (A Dream), artists devised a repertoire of mysterious seers and stylized nymphs emerging from ornate frames. Packages for scented face powders were not mere boxes, but vessels of marvelous dusts designed to perpetuate youth. To be sure, everything was artifice, but it was so successful that France quickly became the leading European exporter of beauty products, and served as the model for how these products were packaged and sold throughout the world. French cosmetic packaging was Art Deco at its most neoclassical in its adaptation of antiquated artifacts, and its most contemporary in the creation of new decoration.

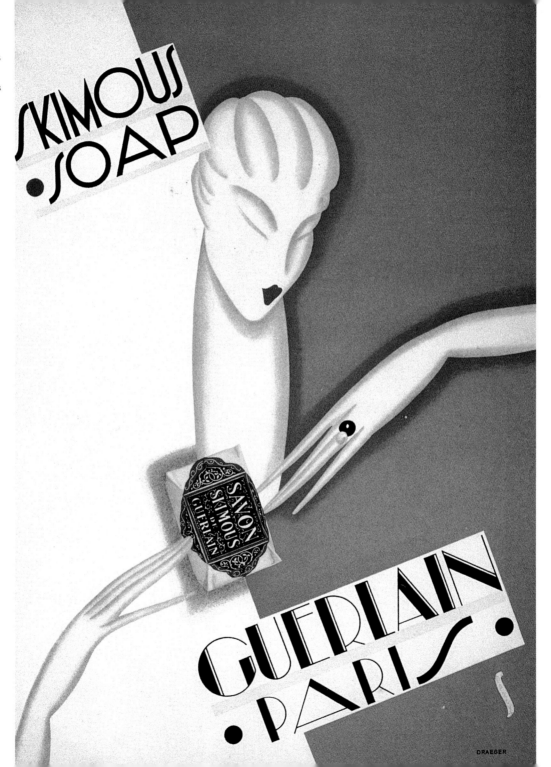

THRIDACE COSMYDOR
SOAP LABEL, c.1925
ARTIST UNKNOWN

LA VIOLETTE DE PARME
SOAP LABEL, c.1925
ARTIST UNKNOWN

COLD CREAM
SOAP LABEL, c.1925
ARTIST UNKNOWN

SOYONS DISCRETS

FRAGRANCE LABEL, c.1927

ARTIST: R. DION

ROSE VÉRITÉ

FRAGRANCE LABEL, c.1927

ARTIST: R. DION

UN RÊVE

FRAGRANCE LABEL, c.1927

ARTIST: R. DION

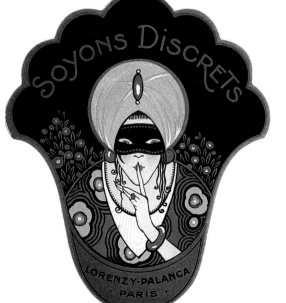

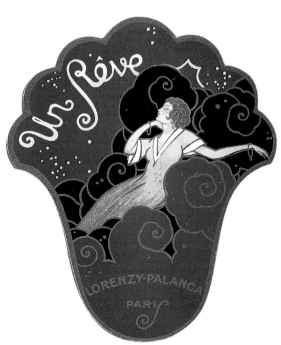

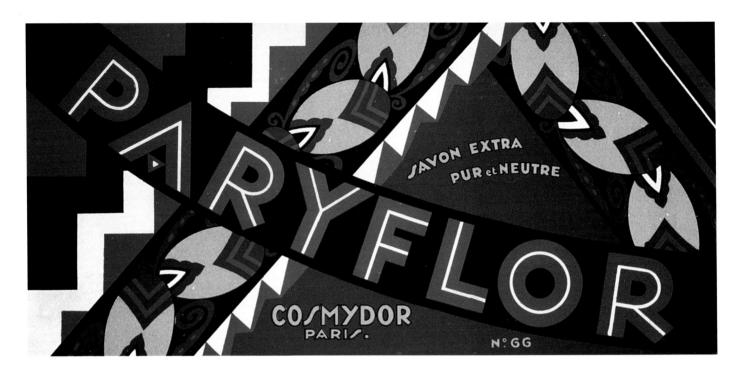

PARYFLOR

SOAP LABEL, C.1925

ARTIST UNKNOWN

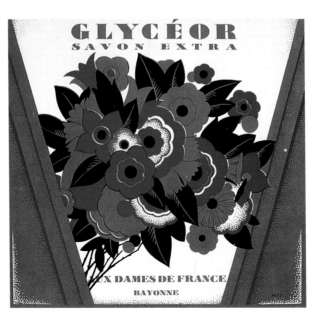

GLYCÉOR

SOAP LABEL, C.1925

ARTIST UNKNOWN

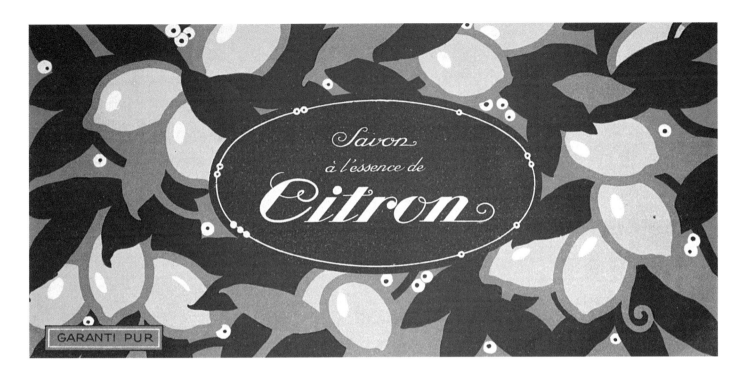

Savon
à l'essence de
Citron

GARANTI PUR

CITRON

SOAP LABEL, c.1925

ARTIST UNKNOWN

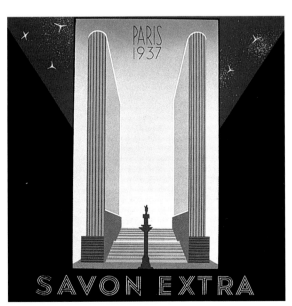

PARIS
1937

SAVON EXTRA

SAVON EXTRA

SOAP LABEL, 1937

ARTIST UNKNOWN

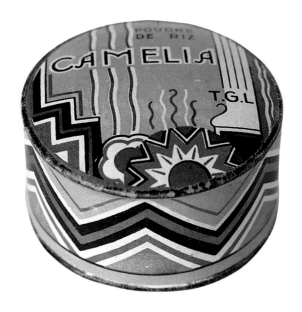

CAMELIA

POWDER BOX, c.1928

ARTIST UNKNOWN

RODOLL

POWDER BOX, c.1928

ARTIST UNKNOWN

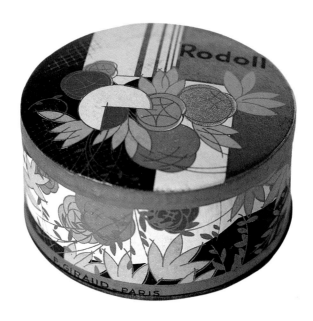

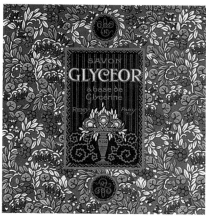

GLYCÉOR

SOAP LABEL, c.1925

ARTIST UNKNOWN

GERALD

SOAP LABEL, c.1925

ARTIST UNKNOWN

CADOLIA

SOAP LABEL, c.1925

ARTIST UNKNOWN

MIEL RÉMY

SOAP LABEL, c.1925

ARTIST UNKNOWN

STADIUM

SOAP LABEL, c.1925

ARTIST UNKNOWN

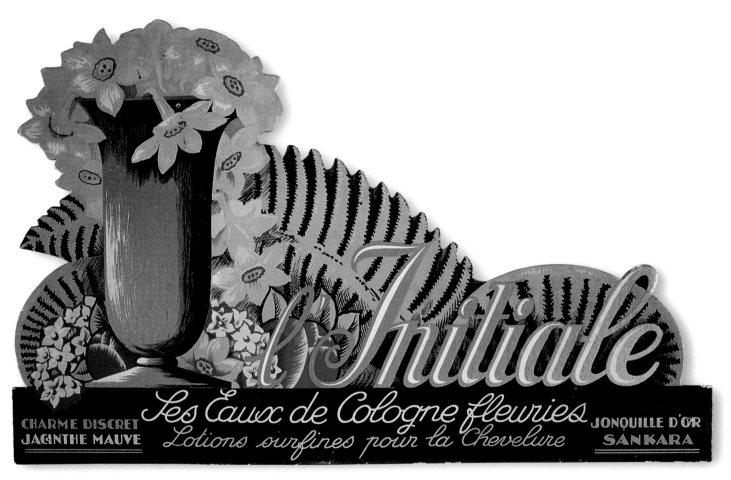

L'INITIALE

POINT-OF-PURCHASE DISPLAY, c.1932

ARTIST UNKNOWN

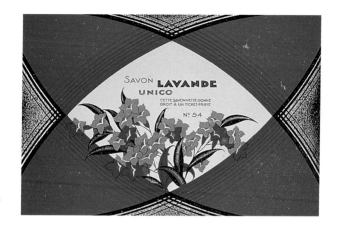

LAVANDE

SOAP LABEL, c.1925

ARTIST UNKNOWN

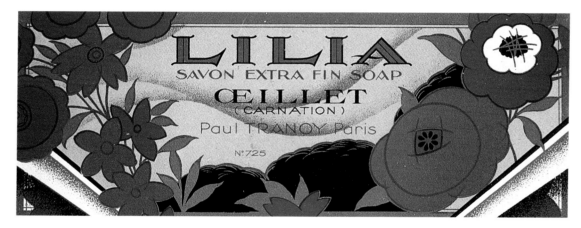

LILIA

SOAP LABEL, c.1925

ARTIST UNKNOWN

LOTION "CAPPI"

COUNTER CARD, c.1928

ARTIST UNKNOWN

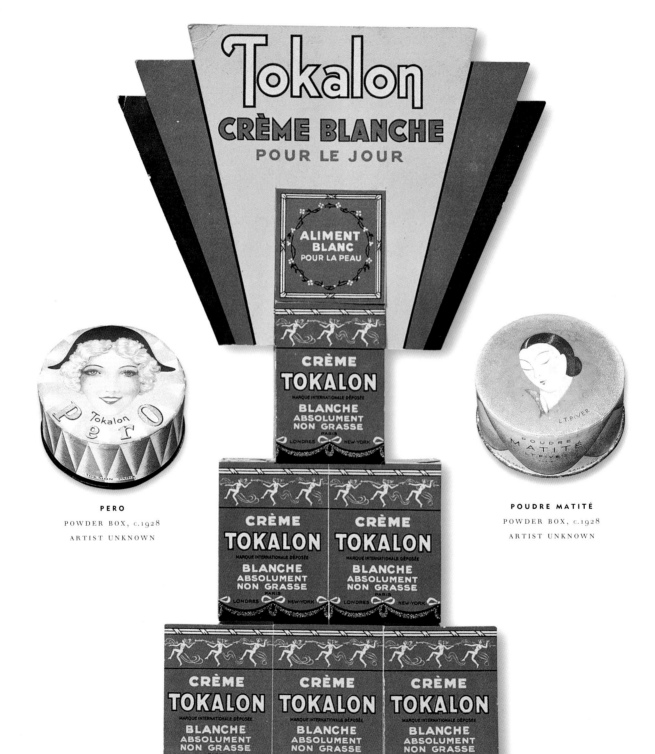

PERO

POWDER BOX, c.1928

ARTIST UNKNOWN

POUDRE MATITÉ

POWDER BOX, c.1928

ARTIST UNKNOWN

OPPOSITE:

TOKALON

POINT-OF-PURCHASE

DISPLAY, c.1930

DESIGNER UNKNOWN

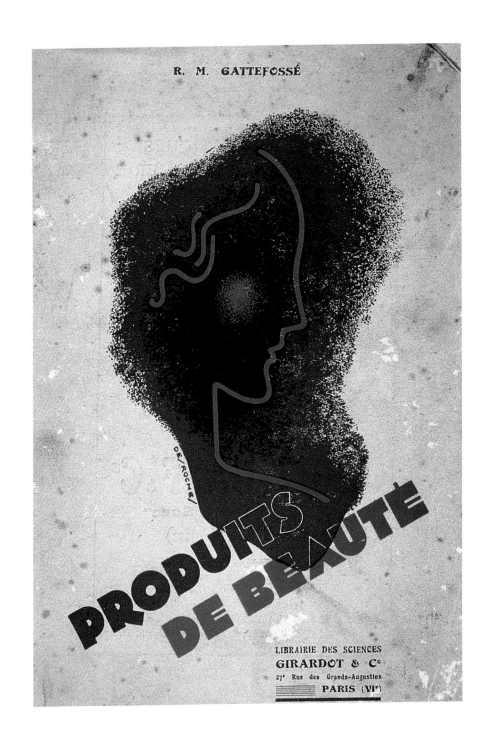

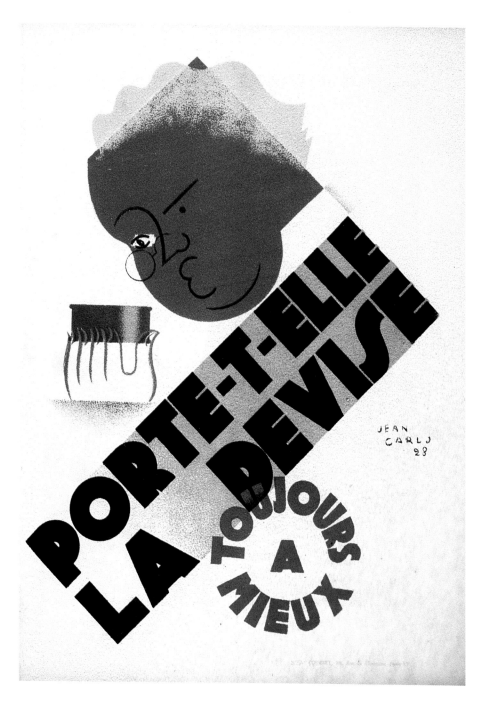

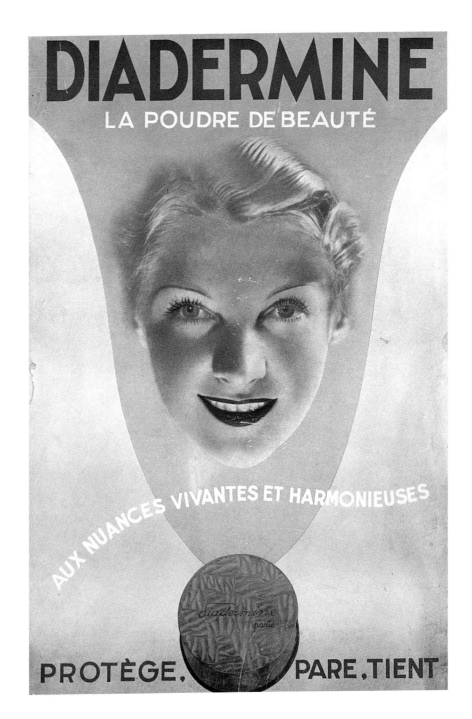

CRÈME

POUDRE

Convient
à tous les
épidermes

Complément
rationnel
de la crème
isoélectrique

GOLATA

POINT-OF-PURCHASE

DISPLAY, 1929

ARTIST UNKNOWN

EAU DE FLEURS

FRAGRANCE LABEL, c.1926

ARTIST UNKNOWN

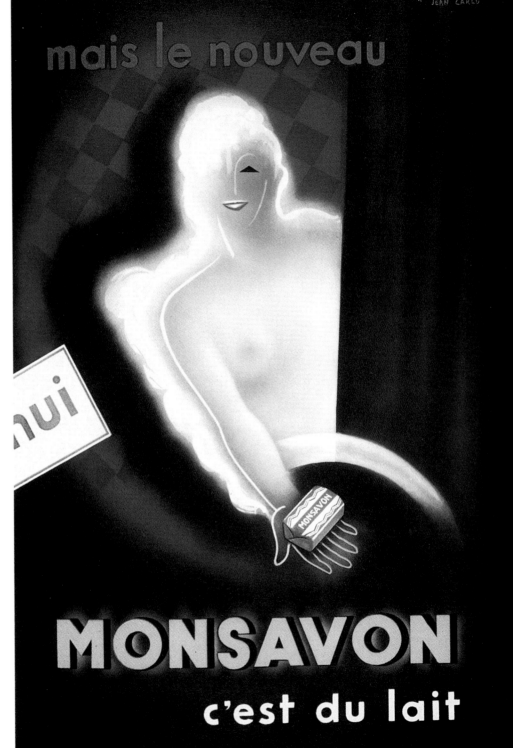

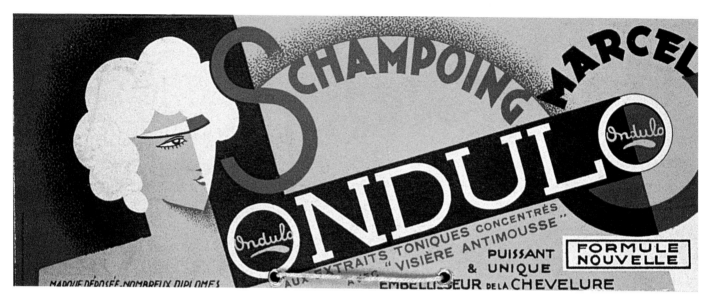

ONDULO

SHAMPOO PACKAGE, c.1931

ARTIST UNKNOWN

SCHAMPOING MARCEL

SHAMPOO PACKAGE, c.1935

ARTIST UNKNOWN

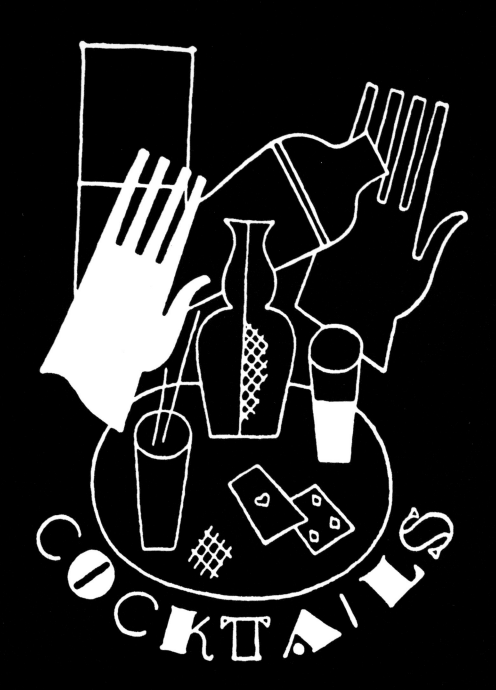

COCKTAILS

The Moderne era is known for many things, not the least of which is cocktails. Few cities in the world are better known for ritual libations than Paris. It is no coincidence that the beverages and the words used to describe many of the world's most popular alcoholic drinks are French: liqueur, aperitif, cognac, champagne, and *vin (rouge et blanc)*. Like those of fashion and cosmetics, the wine and liquor industries during the 1920s and '30s were among France's most profitable. And, owing to great competition between brands, no expense was spared on advertising and promoting them. The leading artists were paid large sums to mythologize products with images that were historical, fanciful, and sensual. Like sports stadiums today, cafés and bars drowned in the logos of the leading sponsors, which were affixed to anything from napkins to umbrellas. In addition, fanciful

FOOD & DRINK

posters and press advertisements featured witty mascots for leading brands such as Bonal, St. Raphaël, and Dubonnet. Consumers were treated to a plethora of premiums, including the ubiquitous advertising fan. This two-sided, hand-held mini-billboard featured a wide array of images designed to stimulate a ravenous thirst. Other foods and soft drinks were aggressively promoted as well. Enamel signs, point-of-purchase displays, and counter cards sold France's respective brands through stylized graphics that had appetite appeal and held artistic sway over the advertising culture. In addition to the elegant Moderne motifs, graphic humor was a powerful tool for transforming something such as a simple grain into a unique culinary experience. The package designs usually ignored the contents in favor of presenting graphic allure. Moderne typefaces, geometric patterns, and neoclassical motifs gave the product an aura as mythic as any fashion advertisement or cosmetic package.

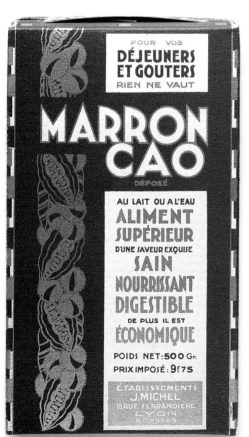

BISCUITERIE PAUL
CANTREAU
PACKAGE, c.1930
DESIGNER UNKNOWN

MARRON CAO
PACKAGE, 1932
DESIGNER UNKNOWN

STELLO STANISLAS
PACKAGE, c.1935
DESIGNER UNKNOWN

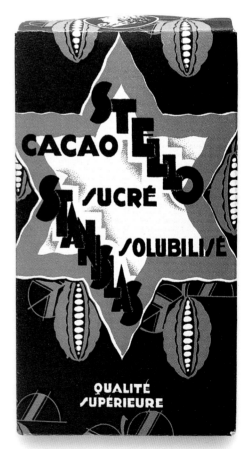

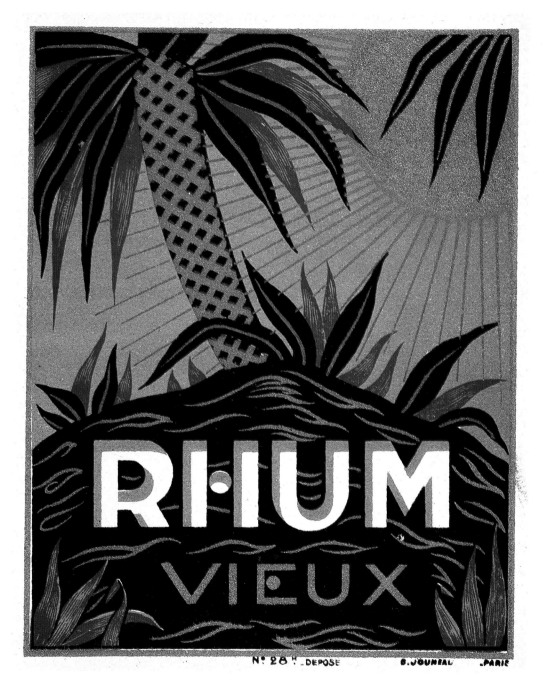

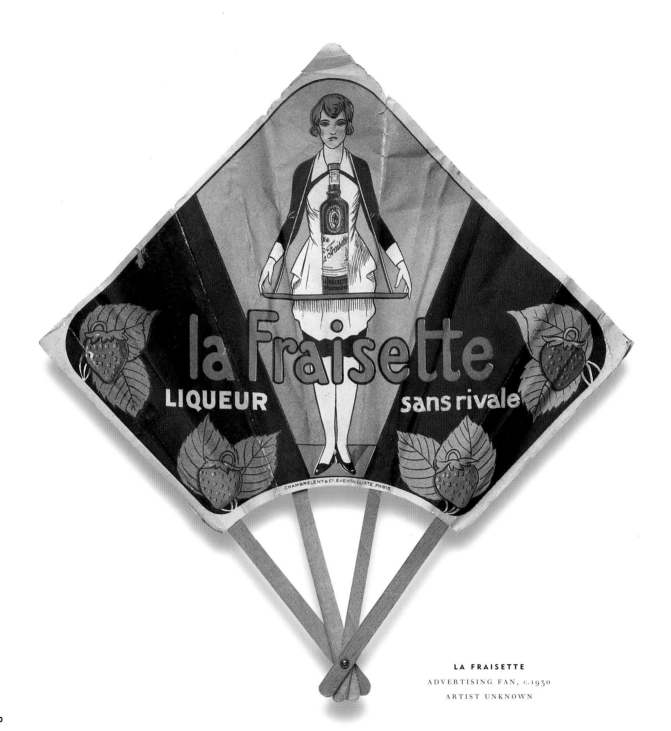

LA FRAISETTE

ADVERTISING FAN, c.1930

ARTIST UNKNOWN

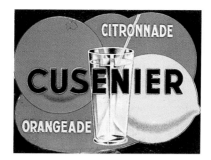

CUSENIER
COUNTER CARD, 1938
ARTIST UNKNOWN

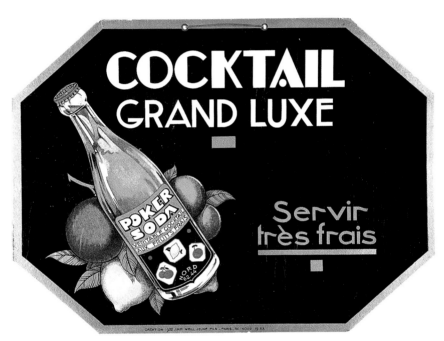

COCKTAIL GRAND LUXE
COUNTER CARD, c.1930
ARTIST UNKNOWN

KATO SPORT
COUNTER CARD, c.1930
ARTIST UNKNOWN

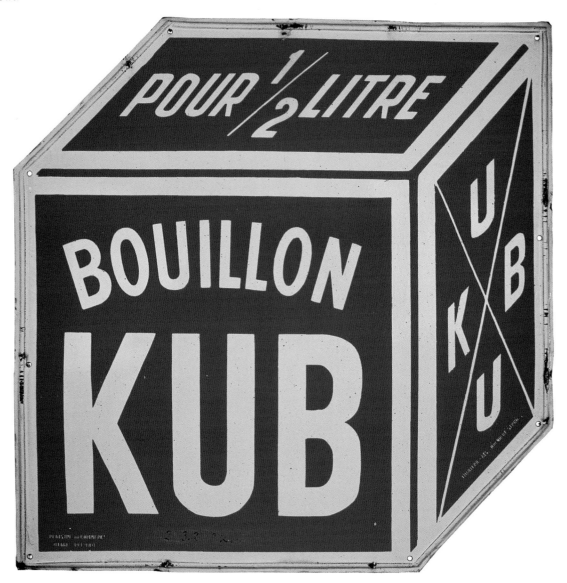

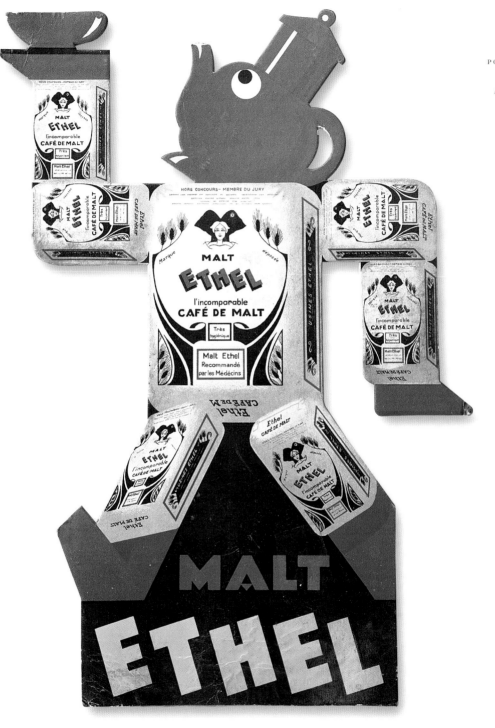

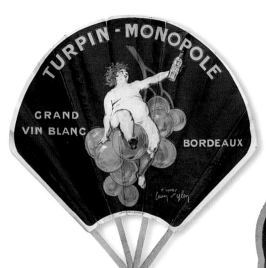

TURPIN-MONOPOLE
ADVERTISING FAN, c.1928
IN THE STYLE OF LEAN & YLEN

BONAL
ADVERTISING FAN, c.1931
ARTIST UNKNOWN

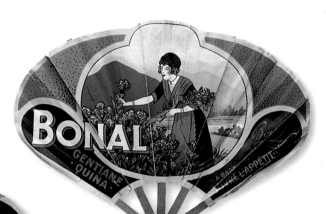

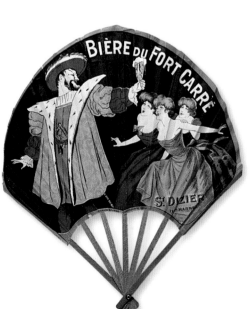

BIÈRE DU FORT CARRÉ
ADVERTISING FAN, c.1925
ARTIST: ST. DIZIER

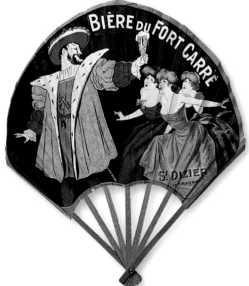

PIKINA
ADVERTISING FAN, c.1930
IN THE STYLE OF ANI LOSER

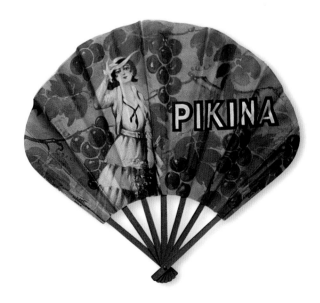

AMOURETTE
ADVERTISING FAN, c.1925
IN THE STYLE OF E.M. RAHUEL

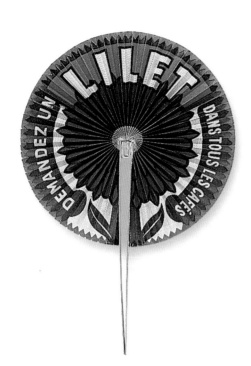

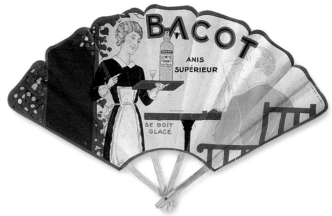

LILET
ADVERTISING FAN, c.1925
DESIGNER UNKNOWN

BACOT
ADVERTISING FAN, c.1930
ARTIST UNKNOWN

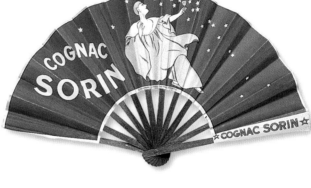

CARCASSO OR-KINA
ADVERTISING FAN, c.1925
DESIGNER UNKNOWN

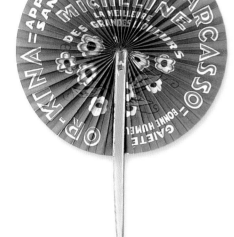

COGNAC SORIN
ADVERTISING FAN, c.1925
ARTIST UNKNOWN

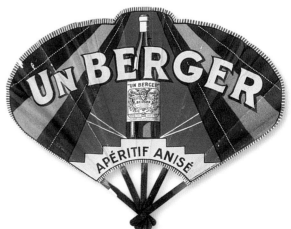

UN BERGER
ADVERTISING FAN, c.1930
ARTIST UNKNOWN

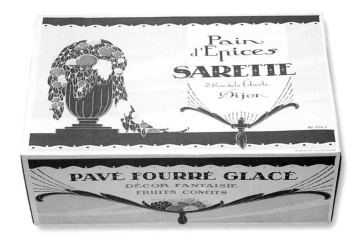

SARETTE

PACKAGE, 1928

ARTIST UNKNOWN

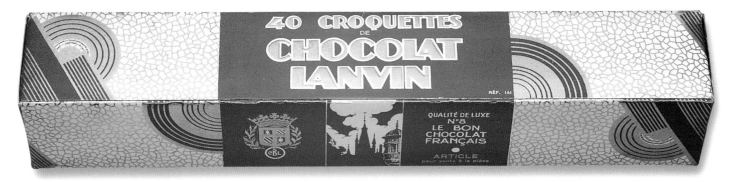

CHOCOLAT LANVIN

PACKAGE, 1935

DESIGNER UNKNOWN

KOLA DE FRUTAS

LABEL, c.1925

ARTIST UNKNOWN

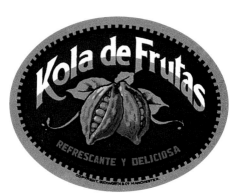

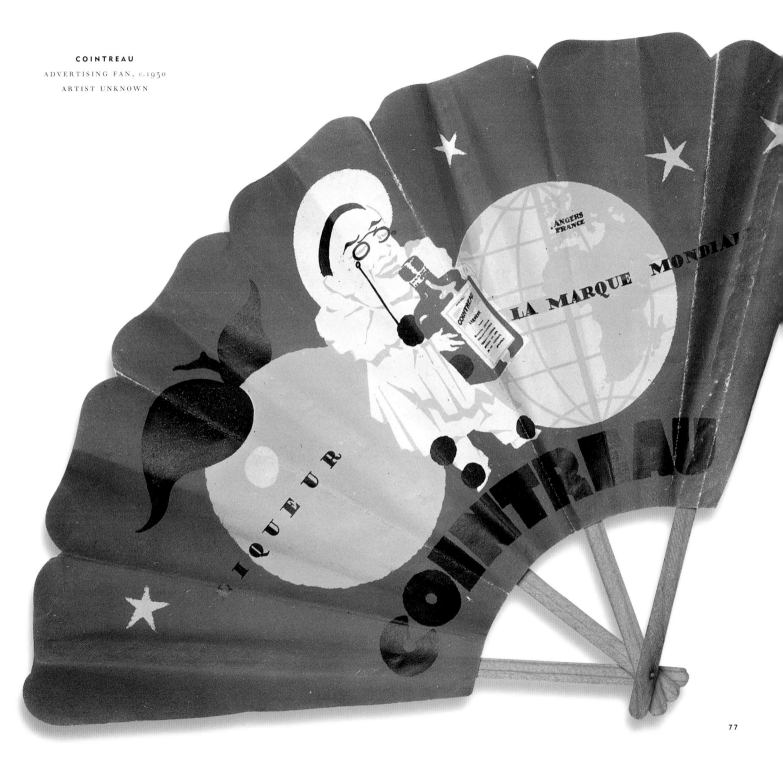

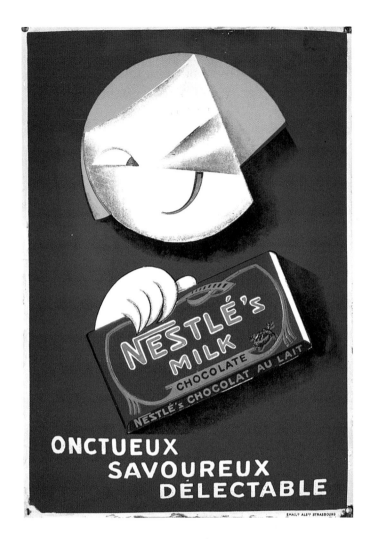

NESTLÉ

ENAMEL SIGN, 1929

ARTIST UNKNOWN

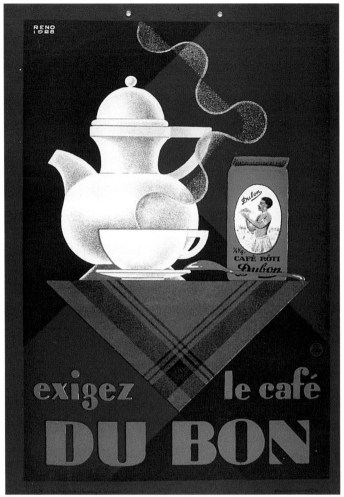

DU BON

COUNTER CARD, 1928

ARTIST: RENO

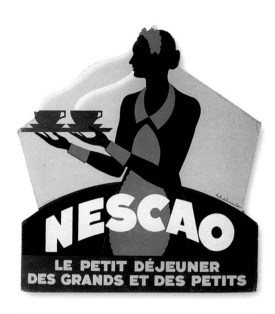

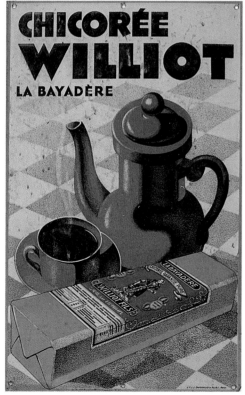

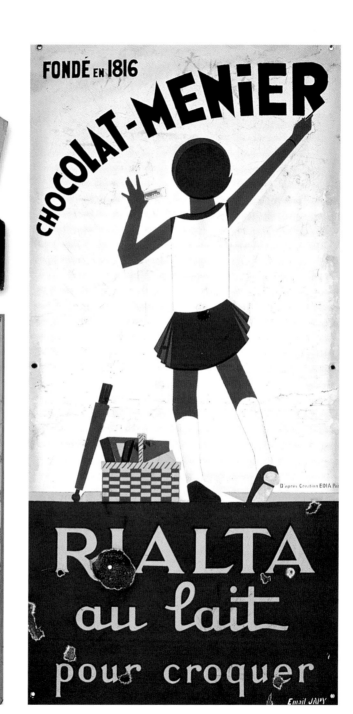

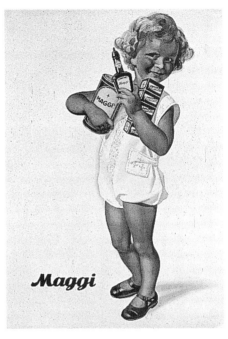

MAGGI

POSTER, 1938

ARTIST UNKNOWN

CHOCOLAT NESTLÉ

POSTER, c.1931

ARTIST UNKNOWN

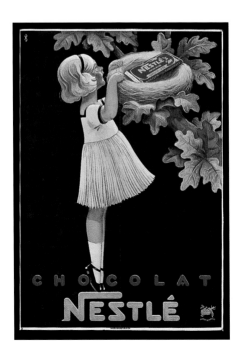

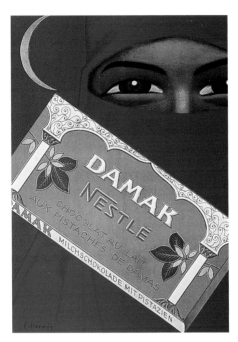

DAMAK NESTLÉ

POSTER, c.1934

ARTIST: E. HERMÈS

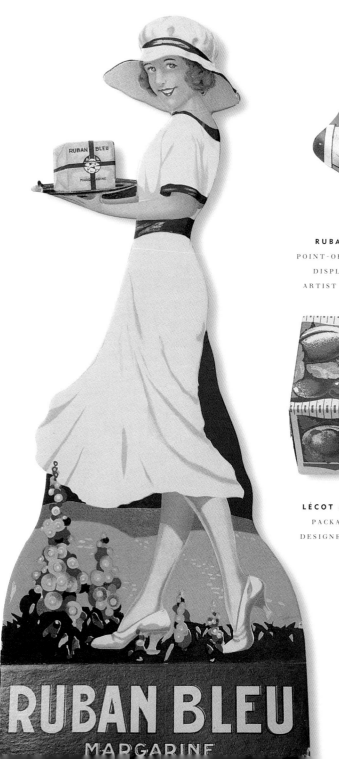

RUBAN BLEU

POINT-OF-PURCHASE
DISPLAY, 1926
ARTIST UNKNOWN

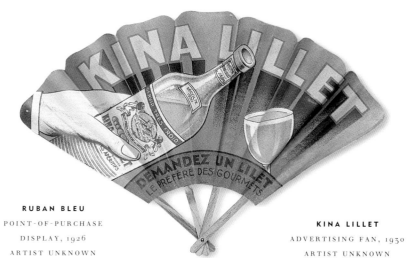

KINA LILLET

ADVERTISING FAN, 1930
ARTIST UNKNOWN

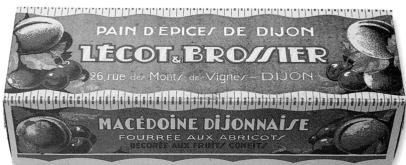

LÉCOT & BROSSIER

PACKAGE, c.1935
DESIGNER UNKNOWN

SAVORA

PACKAGE, c.1928
DESIGNER UNKNOWN

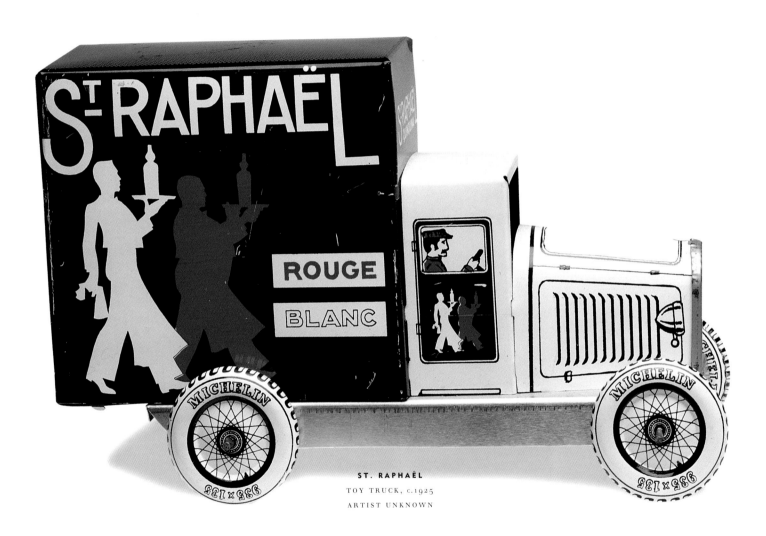

ST. RAPHAËL

TOY TRUCK, c.1925

ARTIST UNKNOWN

OPPOSITE:

QUINQUINA BOURIN

ADVERTISING FAN, c.1928

ARTIST UNKNOWN

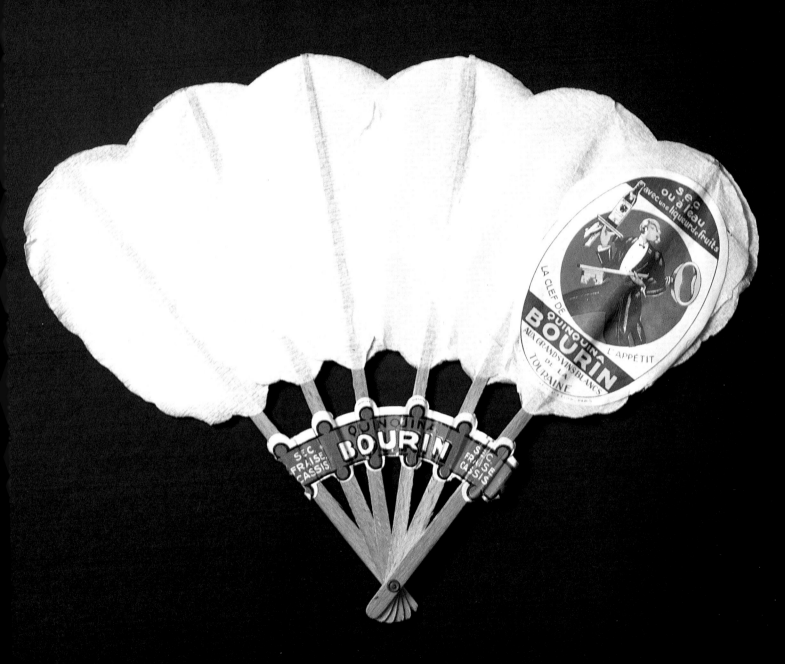

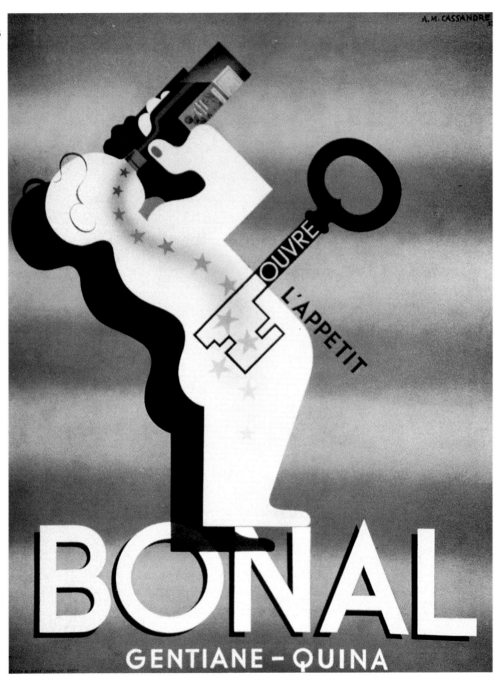

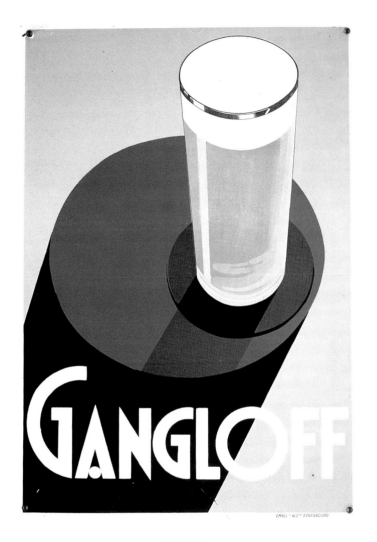

GANGLOFF

ENAMEL SIGN, 1930

ARTIST UNKNOWN

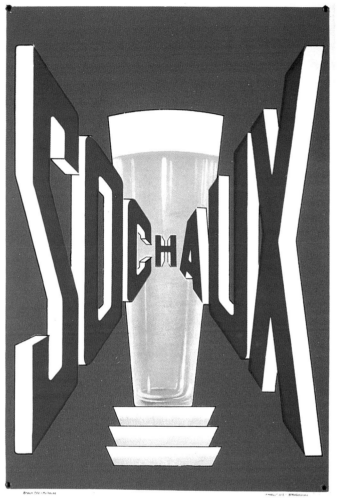

SOCHAUX

ENAMEL SIGN, 1925

ARTIST: BRAUN EDIT-MULHOUSE

The leading French poster artists owed a great debt to the painter Fernand Léger, whose canvases full of anonymous, Futuristic characters appear to have been created on a factory assembly line. The fragmentation and layering of images used in most Modern and Moderne graphics further symbolized the effect of the machine age on French art and society. Unlike the fin de siècle period of art, when advertising ignored the existence of the machine by masking it with floriated or fanciful decoration, the work of the leading French commercial artists interpreted, and even celebrated, a machine aesthetic both through abstract depictions of machines and the introduction of mythical machine-gods which embodied the new era. French Modern design never totally embraced the Italian Futurist's graphic obsession with speed, the American's adoption of the streamline veneer,

INDUSTRY

or other more radical machine age iconography, but it did not deny the new age. Instead, French graphics maintained a balance between Futuristic and nostalgic conceit. Typical imagery was forward-looking while firmly planted in the present. Dynamic typography—bold sans serif typefaces set in novel, asymmetric compositions—signified contemporaneity, while witty renderings of anthropomorphic machinery took the edge off of the imagery, preventing it from becoming too technological and mechanistic. French manufacturers went to great pains not to alienate their clientele by presenting overly avant-garde concepts, but they could not simply advertise such machine age wonders as furnaces, electrical items, or Pyrex pots and pans without introducing a degree of abstraction. Graphics for industry, therefore, relied on Moderne styling to capture attention, while giving the consuming public a more-or-less clear image of the product, designed to sell in the here and now.

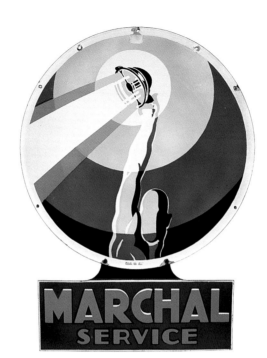

MARCHAL SERVICE

ENAMEL SIGN, 1926

IN THE STYLE OF ROGER PERROT

RADIO-L.L.

ENAMEL SIGN, 1930

IN THE STYLE OF LUCIEN LEVY

FRANCIA

ENAMEL SIGN, 1940

ARTIST UNKNOWN

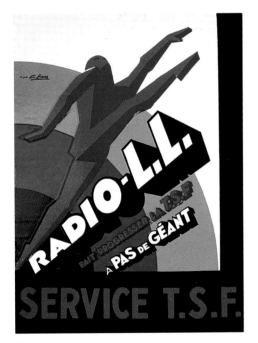

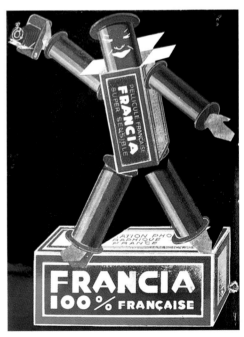

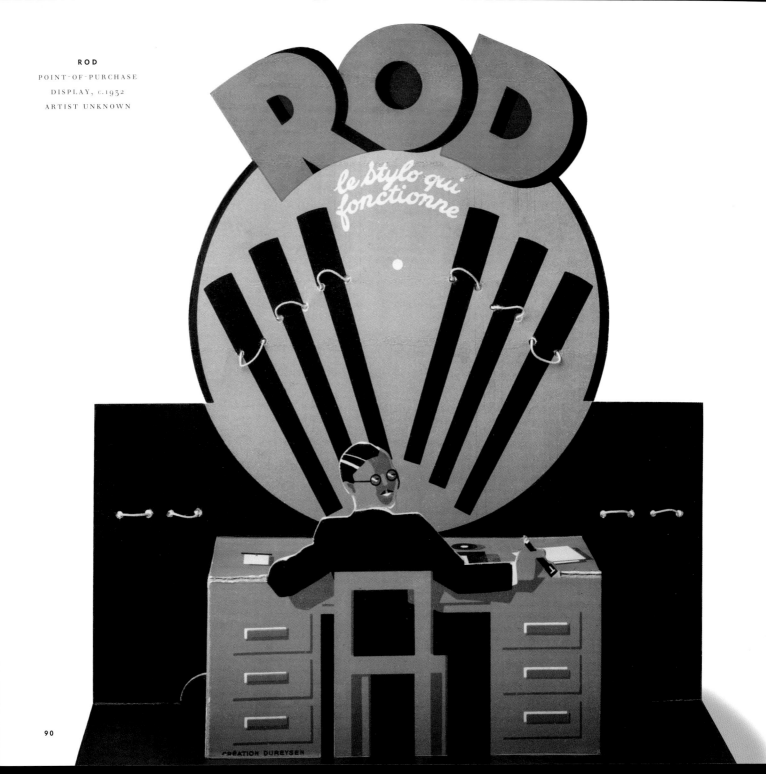

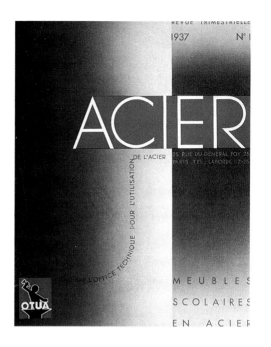

ACIER

CATALOG COVER, 1937

ARTIST: A.M. CASSANDRE

CHAUFFAGE DEVILLE

POSTER, 1935

ARTIST: JEAN CARLU

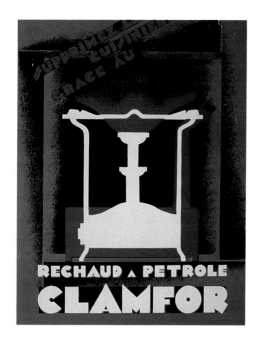

CLAMFOR

POSTER, c.1930

ARTIST: PATRICK

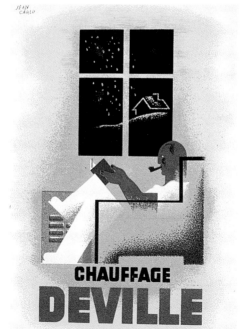

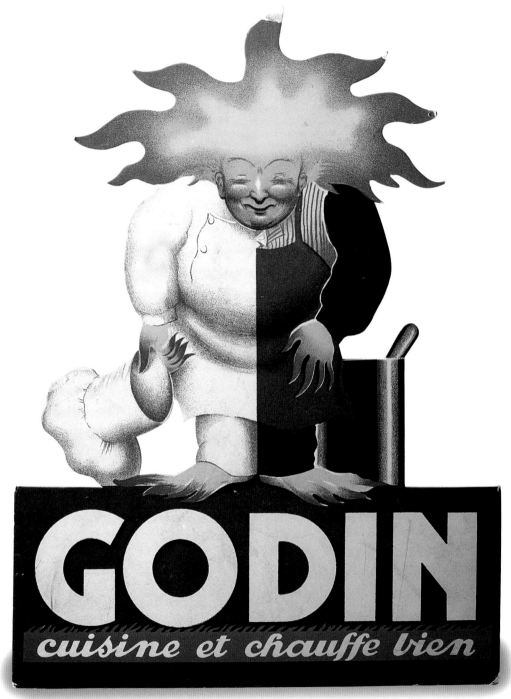

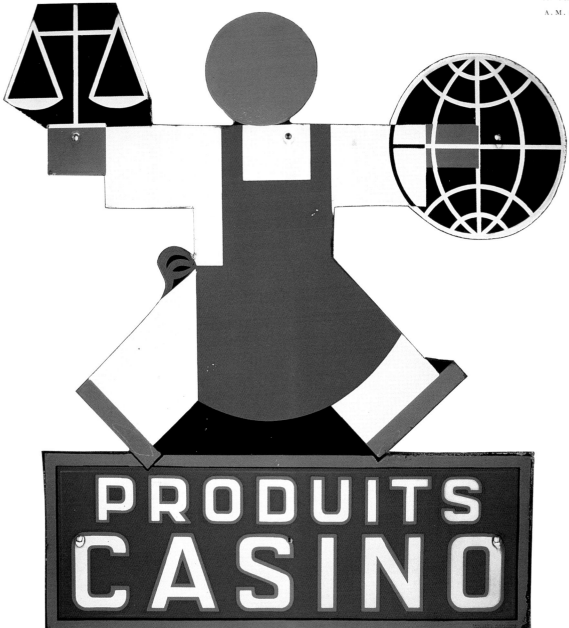

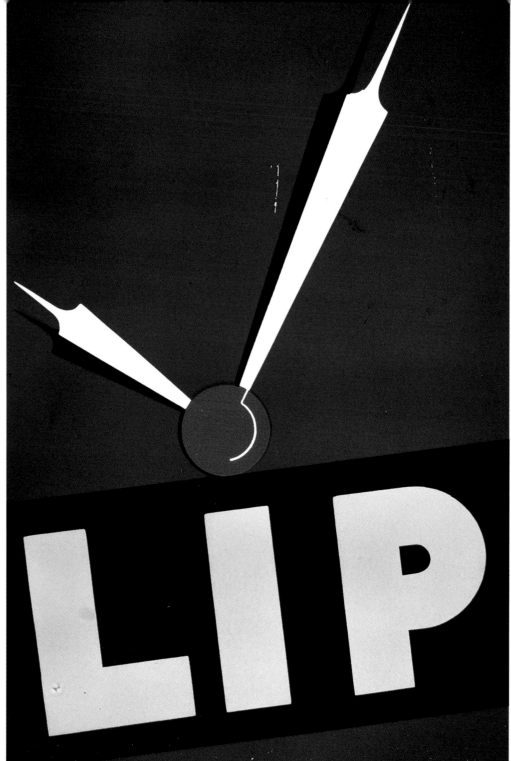

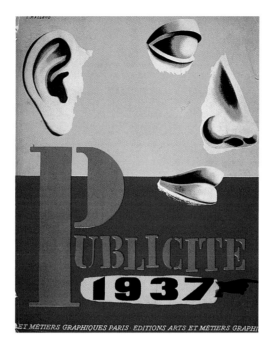

PUBLICITÉ

MAGAZINE COVER, 1934

ARTIST: JEAN CARLU

PUBLICITÉ

MAGAZINE COVER, 1936

ARTIST: JEAN CARLU

PUBLICITÉ

MAGAZINE COVER, 1937

ARTIST: L. MAZENOD

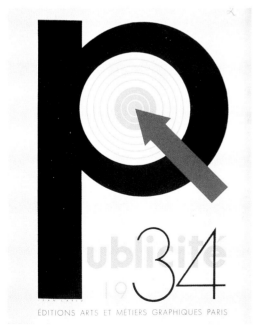

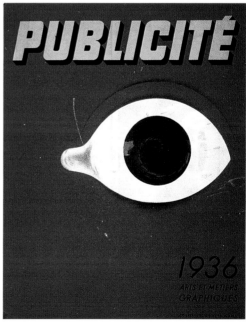

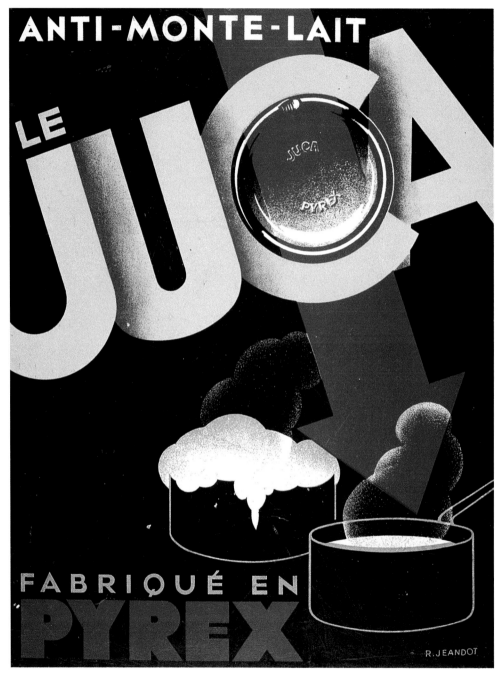

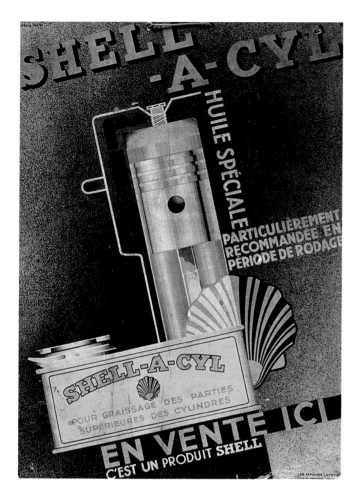

SHELL-A-CYL

POSTER, c.1930

ARTIST UNKNOWN

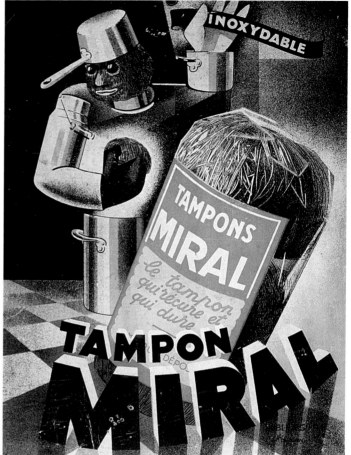

TAMPON MIRAL

POSTER, c.1935

ARTIST UNKNOWN

TUNGSRAM

Sécurité dehors

qualité dedans

TUNGSRAM · BARIUM TUBE

**LAMPES AMÉRICAINES
LAMPES EUROPÉENNES**

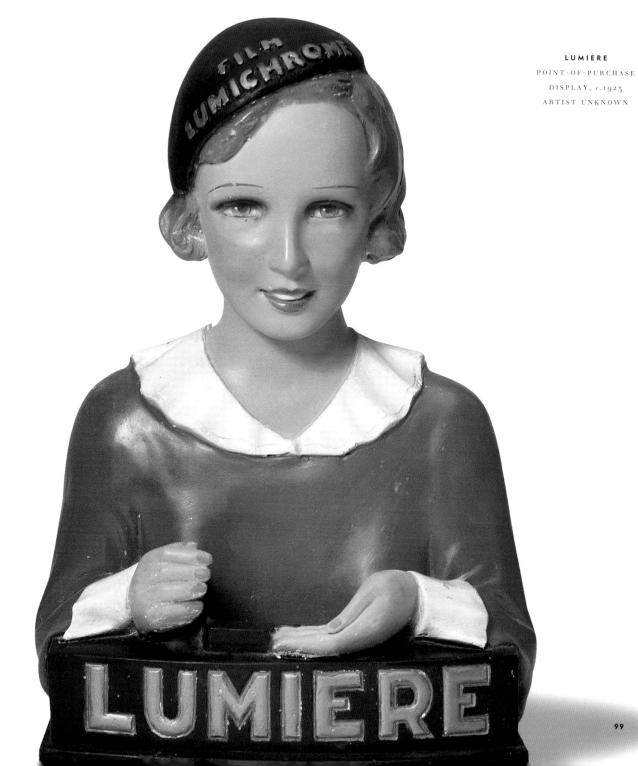

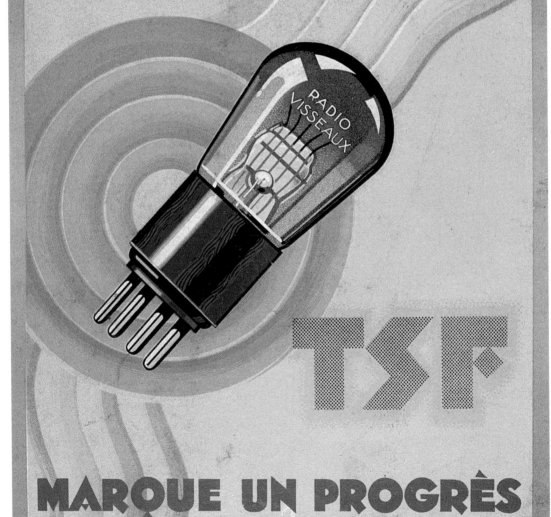

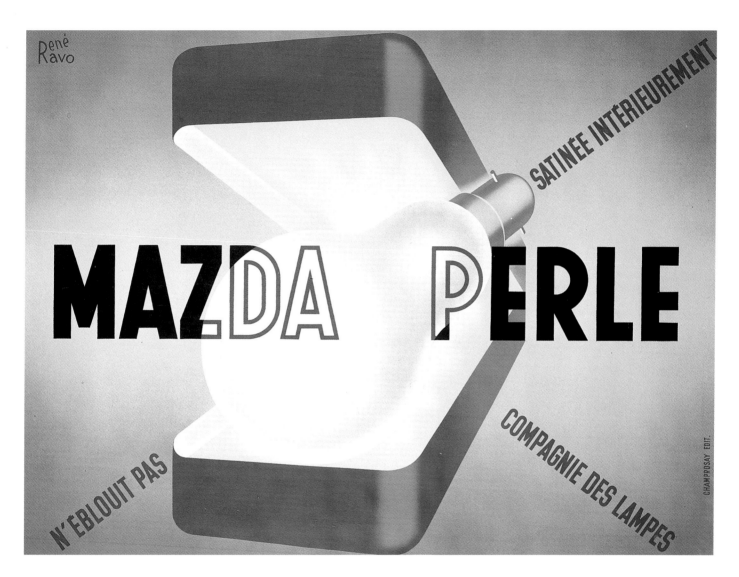

René Ravo

MAZDA PERLE

SATINÉE INTÉRIEUREMENT

N'EBLOUIT PAS

COMPAGNIE DES LAMPES

CHAMPROSAY EDIT.

OPPOSITE:

VISSEAUX RADIO

COUNTER CARD, c.1928

ARTIST UNKNOWN

MAZDA PERLE

POSTER, c.1937

ARTIST: RENÉ RAVO

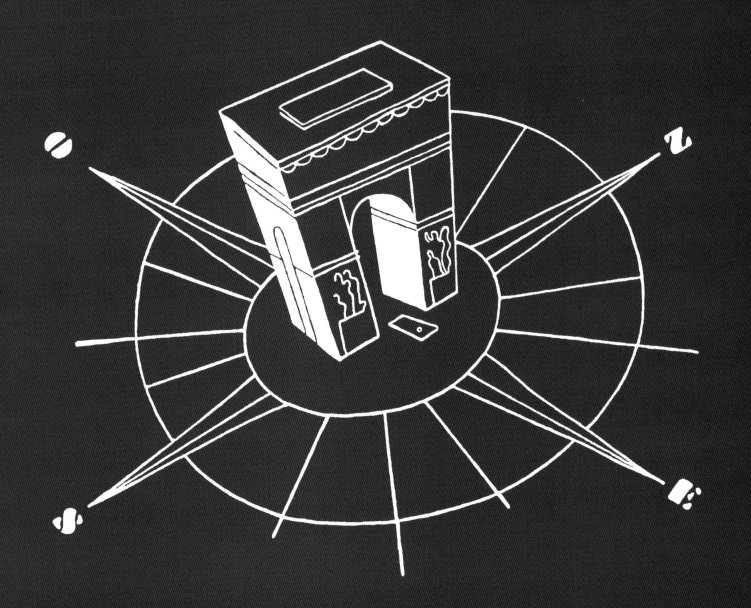

Nothing was more emblematic of French Moderne elegance than its private fleets of huge, luxurious oceanliners, not the least of which was the *Normandie*. On the posters of the day it was transformed by artists into a mythic icon, grand like Renaissance architecture. Nothing except for the powerful locomotives that pulled France's speedy luxury trains—*les wagons-lits*—were as heroicized in enchanting advertising images that made one yearn to journey to distant lands. Both means of travel provided the *affichiste* with extraordinary opportunities to express modernity. These images, added to those of airplanes, motorcycles, and automobiles, completed the basic graphic vocabulary of speed in the early twentieth century. With travel and transportation, artists address the most recurring theme of modern life—the marriage of man and machine—so these images had

T R A V E L

great appeal for consumers with wanderlust and vivid fantasy lives. Furthermore, France's economy owed much of its success to tourism, and while many of the posters and newspaper and magazine advertisements focused on the specific means of transport, many more featured the actual destination. Travel posters imbued these places with quintessential Moderne styling and contributed to the impression that tourism was a culturally exalted endeavor. In France a trend known as the colonial style developed when Moderne graphic conceits were combined with the indigenous graphics of any of France's numerous Asian and African colonies. This added visual dimension and expanded the French Modern lexicon, making it ever more exotic, romantic, and eccentric. Travel poster artists captured more than a sense of place; they immortalized the monument. Through these images the world, in turn, began to see France as the launchpad for remarkable global adventures.

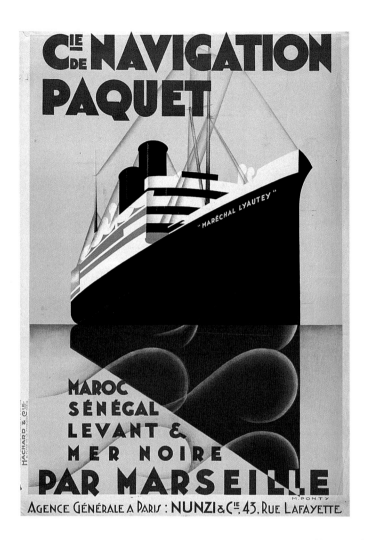

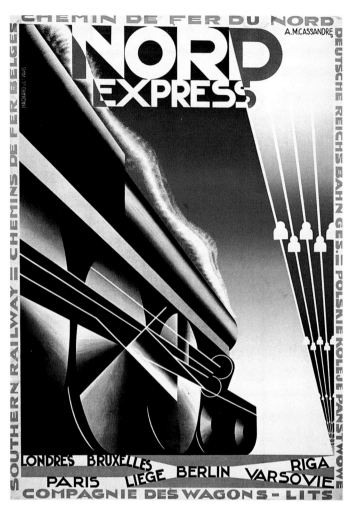

NAVIGATION PAQUET

POSTER, 1938

ARTIST: M. PONTY

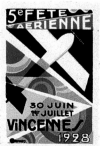

VINCENNES

POSTER STAMP, 1928

ARTIST: ORMAND

NORD EXPRESS

POSTER, 1927

ARTIST: A.M. CASSANDRE

OPPOSITE:

FOIRE DE MARSEILLE

POSTER, 1927

ARTIST: ROGER PÉROT

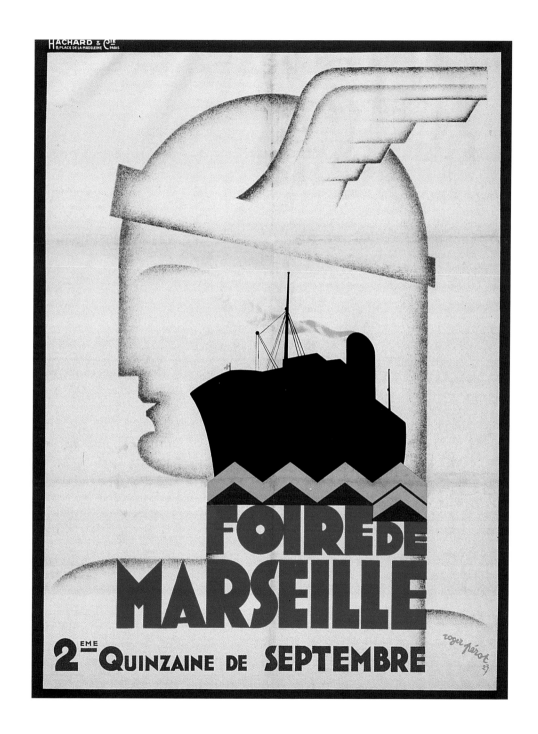

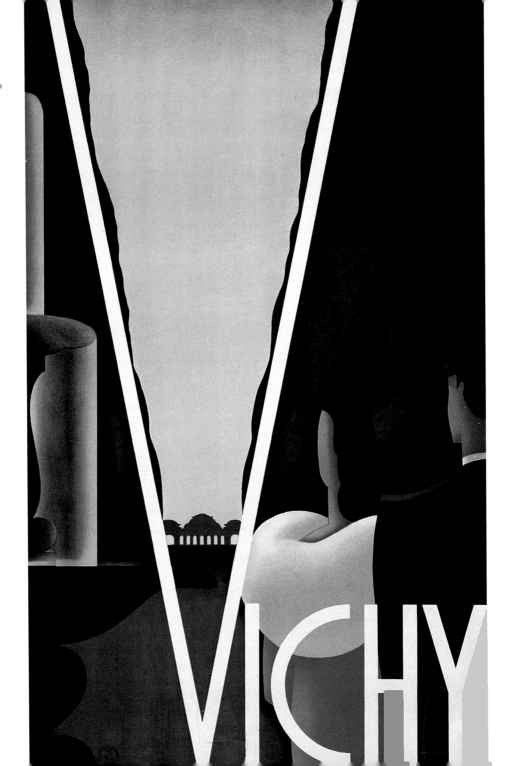

CHEMINS DE FER DE L'EST

POSTER, 1929

ARTIST: THEODORO

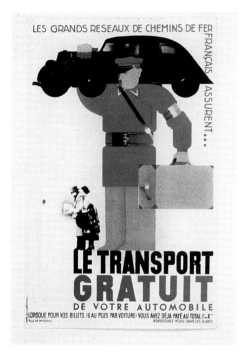

LE TRANSPORT GRATUIT

POSTER, 1930

ARTIST: FIX-MASSEAU

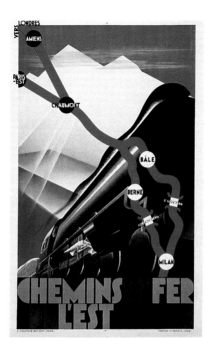

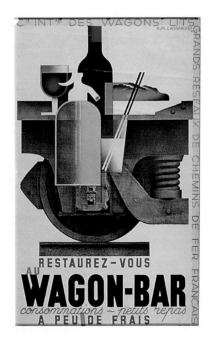

PARIS-LIÈGE

POSTER, 1930

ARTIST: J.P. JUNOT

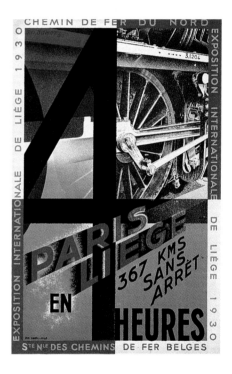

WAGON-BAR

POSTER, 1928

ARTIST: A.M. CASSANDRE

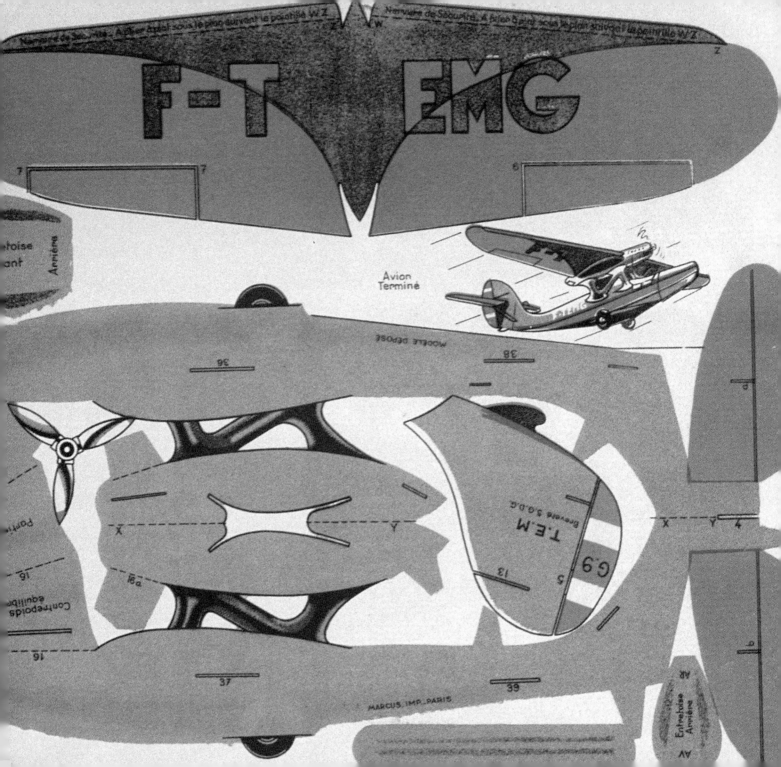

Avion Terminé

MARCUS. IMP. PARIS.

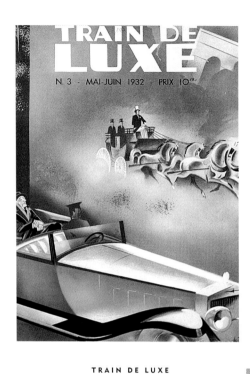

PREVIOUS SPREAD:
PAPER AIRPLANE CUT-OUT, c.1926
ARTIST UNKNOWN

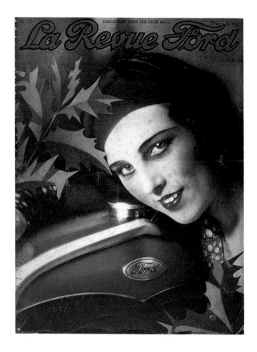

TRAIN DE LUXE

MAGAZINE COVER, 1932

ARTIST: DEROSA

NORD

MAGAZINE COVER, 1931

ARTIST: A.M. CASSANDRE

FORD

CATALOG COVER, 1928

ARTIST UNKNOWN

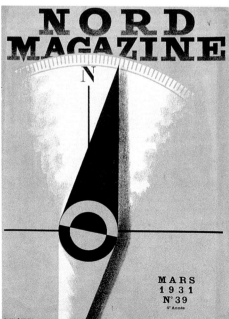

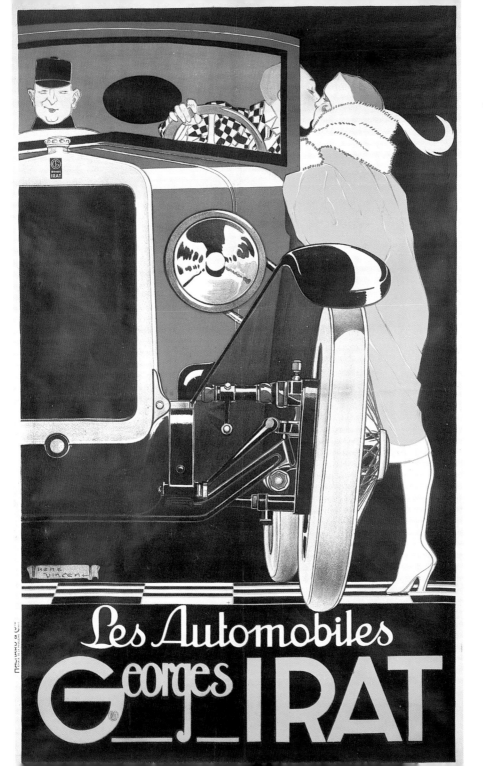

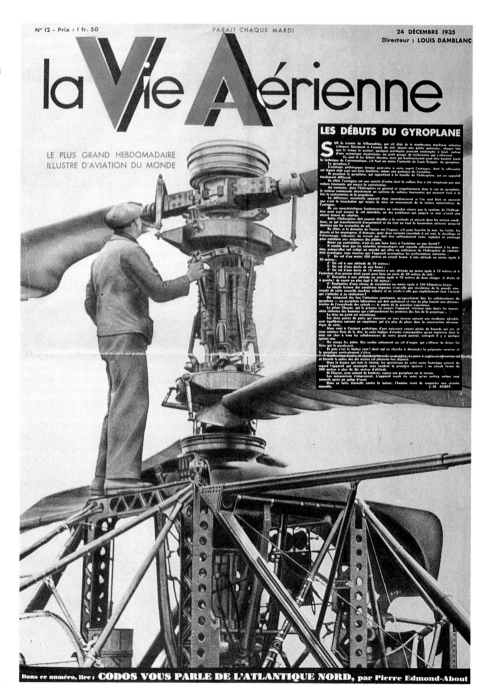

LA VIE AÉRIENNE
NEWSPAPER
FRONT PAGE, 1935
DESIGNER UNKNOWN

In the early 1920s French book typography was criticized for an adherence to convention that amounted to timidity. "Perhaps this monotony is a means of guaranteeing a settled habit of mind on the part of the reader," suggested A. Tolmer in *Mise en Page*. Real freedom in typography, however, could be found in advertising layouts, and particularly in modern posters where the letter was, in the words of A.M. Cassandre, "the leading actor." In the past, text was thoughtlessly added, but in the Modern French poster everything revolved around the word, resulting in integrated compositions of letter, text, and image. The letters were bold and geometric, and had a look unique to the age. Cassandre wrote that he was inclined "not toward a parody of inscription but toward a pure product of the T-square and compass, toward the primitive letter . . . the true letter that is sub-

T Y P O G R A P H Y

stantially monumental" (*A.M. Cassandre*, 1985). Since its inception in the days of Fournier and Didot, French typography has been known for its proportion and elegance, which continued through the modern era. Samuel Welo characterized these alphabets as having "grace and style, in other words the 'chic' so typical of the French people. It is not a letter for bold display but one that creates the atmosphere of refinement" (*Practical Lettering: Modern and Foreign*, 1930). The fount of type innovation was Fonderies Deberny & Peignot, which complemented a large catalog of traditional faces with some of the era's most novel and emblematic ones, including Bifur, Peignot, and Eclair. Through smartly designed tabular catalogs, specimen sheets, and the portfolio of design *Divertissements Typographiques*, and by employing the leaders in the field, Deberny & Peignot influenced a generation of practitioners in the ways of modern typesetting.

**FONDERIES DEBERNY
& PEIGNOT**
CATALOG, 1926
DESIGNER: MAXIMILIEN VOX

OPPOSITE:
PRÉSENTATION ETALAGES
CATALOG COVER, 1927
DESIGNER UNKNOWN

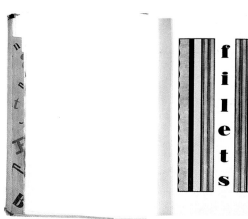

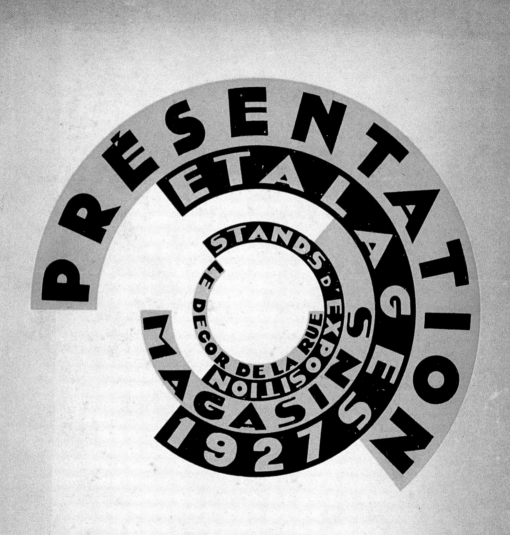

PRÉSENTATION

ETALAGE

STANDS D'EXPOSITION

ET DÉCOR DE LA RUE

MAGASINS

1927

LES ÉDITIONS DE "PARADE" 12, RUE GAILLON - PARIS

A B C D

FE K M P

a b c d e f

p r s v y z

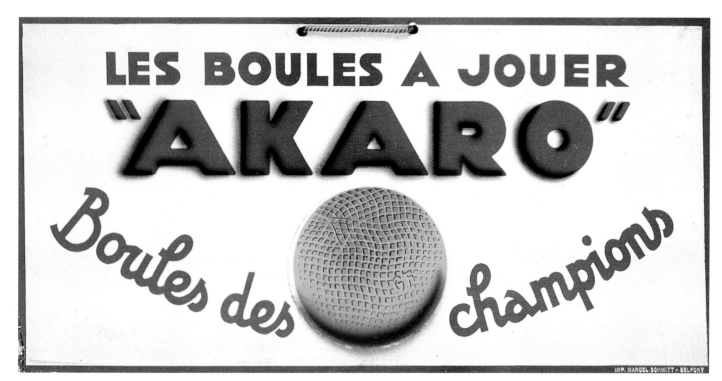

OPPOSITE:
ALPHABET ROMANTIQUE
TYPE SPECIMEN SHEET, 1927
DESIGNER UNKNOWN

MYDIA
LABEL, c.1927
DESIGNER UNKNOWN

AKARO
COUNTER CARD, c.1928
DESIGNER UNKNOWN

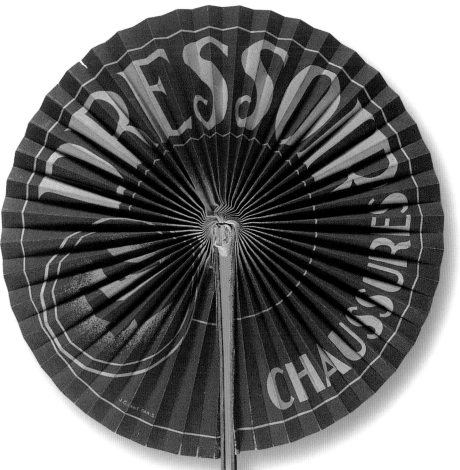

MILK BOTTLE CAPS

TYPE SHOP SAMPLES, c.1925

DESIGNERS UNKNOWN

DRESSOIR

ADVERTISING FAN, c.1923

DESIGNER UNKNOWN

ALPHABETS ET
CHIFFRES MODERNES
TYPE SPECIMEN SHEET, 1927
DESIGNER: A. BARDI

Confidences

RÉGIE FRANÇAISE
S.E.I.T.
DES TABACS

STUDIO
SALERNi
13 ave
de la victoire
nice

LA PARISIENNE

LB&C

STUDIO
MICHELET
ALGER
66 RUE MICHELET

STUDio D'ART
ALZIEU
& R.D ALSACE
ANGERS

A B C D E F

TOUR EIFFEL

AFFICHES

CINEMA-THÉÂTRE

OPPOSITE:
LETTERING SPECIMENS
TYPE SHOP SAMPLES, c.1925
DESIGNERS UNKNOWN

ALPHABETS ET
CHIFFRES MODERNES
TYPE SPECIMEN SHEET, 1927
DESIGNER: A. BARDI

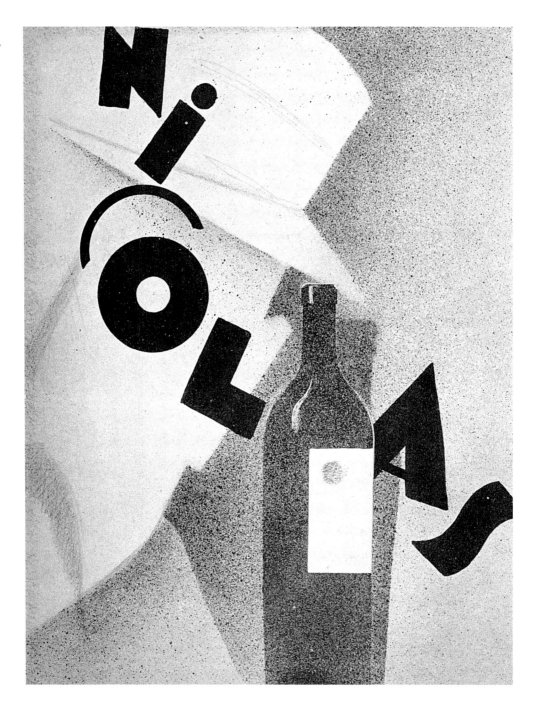

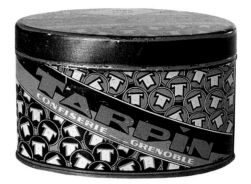

TARPIN

PACKAGE, c.1928

DESIGNER UNKNOWN

AU BON MARCHÉ

COUNTER CARD, c.1928

DESIGNER UNKNOWN

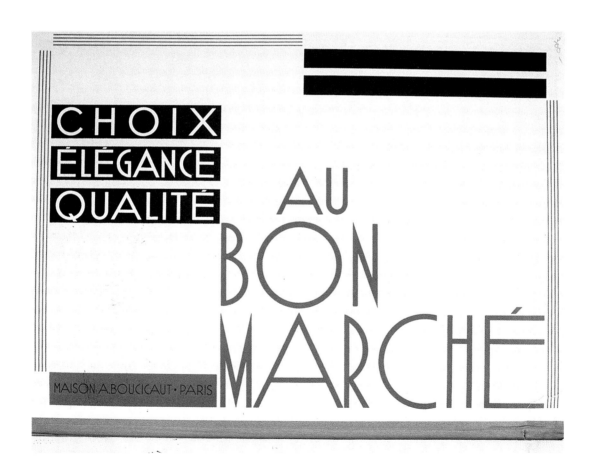

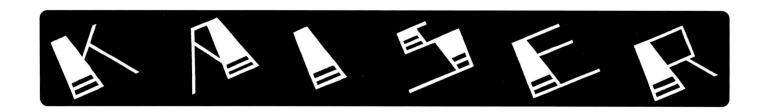

LETTERING SPECIMENS
TYPE SHOP SAMPLES, C.1925
DESIGNERS UNKNOWN

LA DANSE

MAGAZINE LAYOUTS, 1924

DESIGNER UNKNOWN

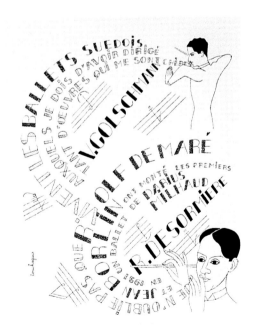

PARIS

PARIS-ROME

TYPE SPECIMEN SHEET, 1927

DESIGNER: A. BARDI

ALPHABETS ET CHIFFRES MODERNES
LETTERING AND MONOGRAM SPECIMENS, c.1925
DESIGNER: ATELIERS PLUMERAU

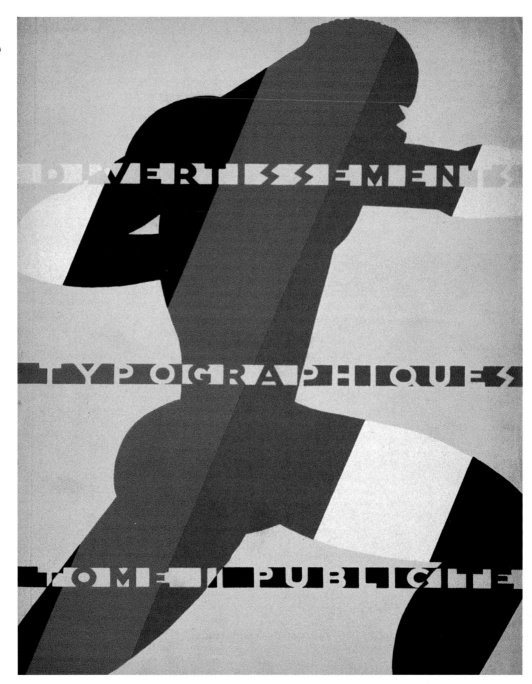

Nous sommes heureux de présenter aux lecteurs d'Arts et Métiers Graphiques l'alphabet et l'échelle d'un caractère inédit destiné à être utilisé dans la publicité.

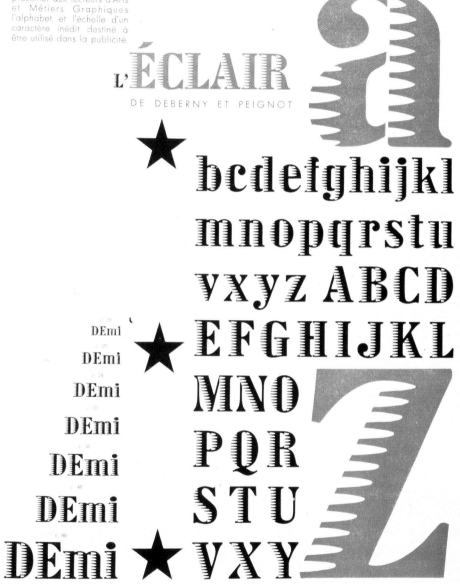

L'ÉCLAIR
DE DEBERNY ET PEIGNOT

BIBLIOGRAPHY

Contina, Frédérique, et al. *Maximilien Vox: Une Homme de Lettres*. Paris: Bibliothèque des Arts Graphiques, 1994.

Courault, Pascal and François Bertin. *Email & Pub*. Rennes: Editions Ouest-France, 1986.

Duncan, Alistair. *Art Deco*. London: Thames and Hudson, 1988.

Email Reklame-Schilder vom 1900 bis 1960 aus der Schweiz, Deutschland, Frankreich, Belgien, und den Niederlanden. Zürich: Museum für Gestaltung Zürich Kunstgewerbemuseum, 1987.

Mercer, F. A. and W. Gaunt, editors. *Modern Publicity: Commercial Art Annual*, 1930. London: The Studio Limited, 1930.

Mouron, Henri. *A. M. Cassandre*. New York: Rizzoli, 1985.

Quand l'Affiche Faisait de la Reclame! L'Affiche Français de 1920 à 1940. Paris: Musée National des Arts et Traditions Populaires, 1991.

Rétrospective Jean Carlu. Paris: Musée de l'Affiche, 1980.

Sica, Grazia Gobbi. *Il Ventaglio Pubblicitario 1890−1940*. Florence: Contini & C., 1991.

Tolmer, A. *Mise en Page*. London: The Studio, 1931.

Welo, Samuel. *Practical Lettering: Modern and Foreign*. Chicago: Frederick J. Drake, 1930.